MODERN ACRYLIC

BLAKELY LITTLE

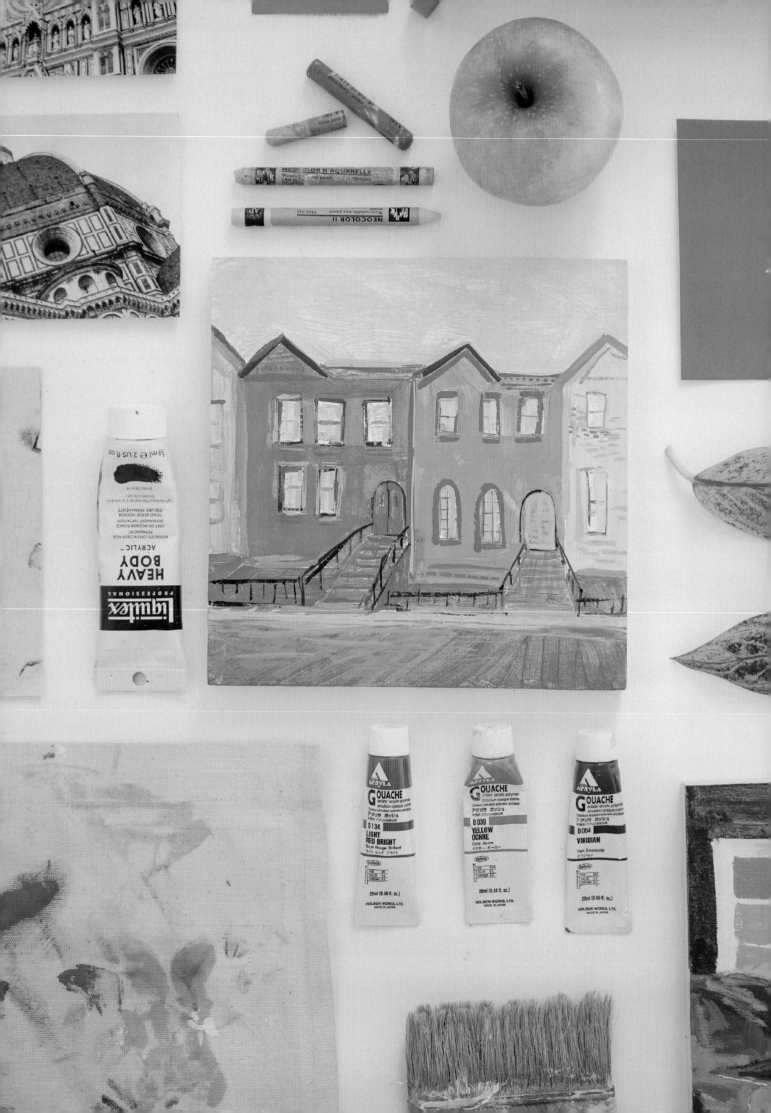

TABLE OF
CONTENTS

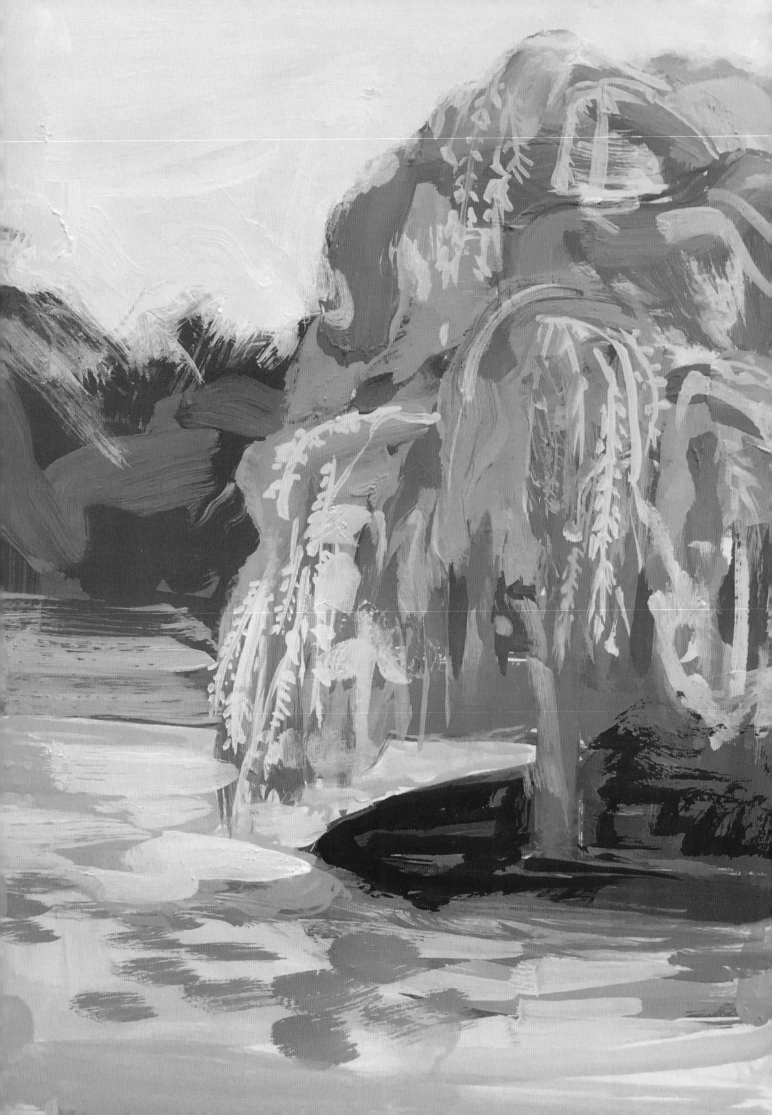

GETTING
STARTED

INTRODUCTION

Have you ever been in a moment and felt the desire to capture it? I don't mean just a quick photo to freeze what it looks like; I mean you want to capture the feeling of it all: the warmth of sand beneath your feet on your first trip to the beach after a long winter, the wind blowing through your car window as your drive through the mountains, the silence in a single, fragile flower. This is painting. Painting is about seeing and feeling, and pushing all those emotions onto a canvas.

Acrylic paints are versatile and can mimic other paints easily, without the hassle of special products. They are tough and permanent and will hold true to their color for years. They don't have any odor and are safe for all ages. You can water down acrylic paint and layer washes of color over and over to build up opaque shades to create new colors. You can lay acrylic paint thickly on a panel—it will dry quickly—and then paint on top of that color without the two mixing and getting muddy.

In this book, we'll explore everything you need to know to get started in acrylic painting, whether you're brand new to art or an experienced artist who just wants to explore a new medium. We'll go over the basic tools and materials, how to handle brushes to achieve certain strokes and textures, how to use color to express yourself, and so much more.

After you've learned these basics, dive into the easy-to-follow step-by-step tutorials, which cover a wide range of subject matter. You can follow along with my projects exactly, or you can put your own personal spin on things by choosing a different color palette, tweaking the subject matter, or simply painting it in your own style—there's no wrong way!

Acrylic paint is simple to work with and has a breadth of uses. Allow your creativity to flow, and keep an open mind while you let the paint do its thing!

SUPPLIES

It's important to prep your space and materials before you begin painting. This way, once you dive in, you can really get creative without trying to find all the things you might need. First clear the space where you will be painting. Put away anything that may get paint on it, and lay down a drop cloth to protect the area. You can work on an easel, a wall, or a flat surface. Think through the way you work best and set it all up. Do you need snacks? Ice water? Comfy clothes? Music? Set a great environment that enables you to be creative yet focused.

BRUSHES

You'll want to grab a big cup of water for your dirty brushes, and then lay them out. Many types of brushes can be used for different paint strokes. Shown here are the brushes I use most. Synthetic-hair brushes are best for acrylics, because the strong filaments can withstand the caustic nature of the paint.

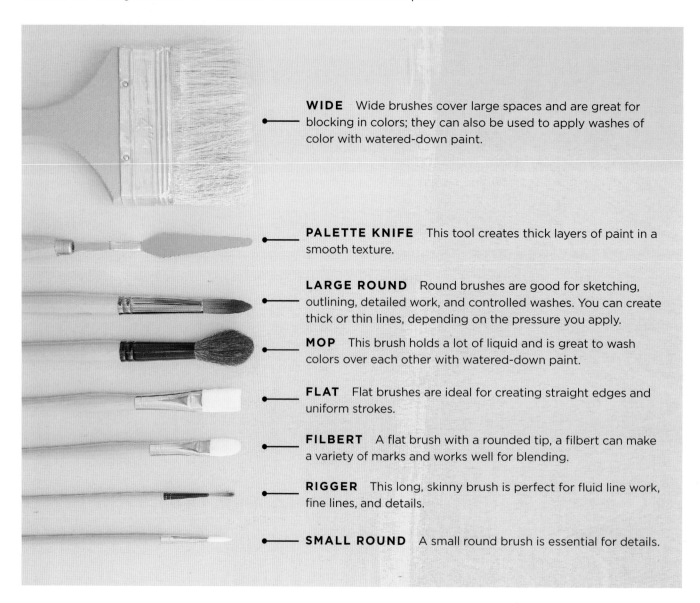

WIDE Wide brushes cover large spaces and are great for blocking in colors; they can also be used to apply washes of color with watered-down paint.

PALETTE KNIFE This tool creates thick layers of paint in a smooth texture.

LARGE ROUND Round brushes are good for sketching, outlining, detailed work, and controlled washes. You can create thick or thin lines, depending on the pressure you apply.

MOP This brush holds a lot of liquid and is great to wash colors over each other with watered-down paint.

FLAT Flat brushes are ideal for creating straight edges and uniform strokes.

FILBERT A flat brush with a rounded tip, a filbert can make a variety of marks and works well for blending.

RIGGER This long, skinny brush is perfect for fluid line work, fine lines, and details.

SMALL ROUND A small round brush is essential for details.

PAINTS

Paint varies in cost by grade and brand, but even reasonably priced paints offer sufficient quality—especially for beginners. Very inexpensive paint may lack consistency and affect your results, but buying the costliest paint may limit you. Find a happy medium. For the projects in this book, basic acrylic paints will be perfect, but you might want to explore some of these other options as well.

BASIC ACRYLICS
The most common acrylic for fine artists has less body than oil paint but much more than watercolor washes. The gel-like consistency forms soft peaks and offers a great middle ground for artists who desire more control than fluid paints allow but without the bulk of thick, heavy paints.

HEAVY-BODY ACRYLICS
This thick, buttery paint with a high viscosity retains brushstrokes and allows artists to form stiffer peaks of paint. It is a great choice for highly textured work that uses painting knives, coarse brushwork, and impasto techniques.

FLUID ACRYLICS
Fluid paint has a low viscosity with a consistency that lies between ink and basic acrylic paint. Fluids settle to a smooth finish and do not retain brushstrokes or peaks. You can achieve wonderful flowing, drippy effects and expressive spattering with this paint.

ACRYLIC INKS
Also called "liquid acrylics," these extremely fluid inks are the thinnest acrylics available. They work well with watercolor techniques such as spattering and glazing. Because they are waterproof, you don't have to worry about disturbing previous layers of paint once dry. They can also be used with an airbrush.

Heavy-body acrylics form higher peaks than regular acrylics, allowing for more textured surfaces.

Fluid paints are pourable and flow into each other beautifully. Here I used a toothpick to pull one color into the next.

PALETTES

There are pros and cons to the different types of palettes available. I've tried them all, and sometimes I use different ones depending on the project I am working on!

GLASS I mainly use a glass palette because of its smooth surface for mixing colors, and it's easily cleaned by scraping off the paint with a razor. It's important that the surface beneath the glass be white, so you can accurately mix the colors. A dark or colored surface will cause the colors to look different on your palette than they do in your painting.

WOOD Wood is usually sturdy and light; if you like to hold your palette while painting, it is the perfect fit. A wood palette can be difficult to clean, however, if you let the colors dry on the palette over long periods of time. I usually prefer a glossy finish on the wood, rather than raw, as it provides a better surface for mixing.

PLASTIC Plastic is also smooth, like glass, but you can't clean it by scraping off the paint. This is another sturdy, but light, option for holding or setting on a table.

DISPOSABLE PALETTES

Most art-supply stores carry pads of disposable palettes. The thin paper has a wax finish on top for holding your paints and mixing. Once you are done, you rip it off, throw it away, and use the next sheet. I use this type of palette when I am working on projects where the colors need to be very clean and separated. Sometimes I even cut it into pieces, so each color has its own palette.

SUPPORTS

A support is simply the surface on which you paint your artwork. Sometimes when I set up to paint, I have an idea of the direction I am going in. I might be working from a sketch and have colors in mind that I want to use. Other times, I get set up, and just begin to work and see where I end up!

Usually, when I have a specific outcome in mind, I consider the three surface options described here.

PAPER The best type of paper for painting is heavyweight watercolor paper, cold- or hot-pressed. This kind of paper works really well for mixed media projects, can handle a few of layers of paint, and is easy to frame under glass once dry.

WATERCOLOR PAPER TEXTURES

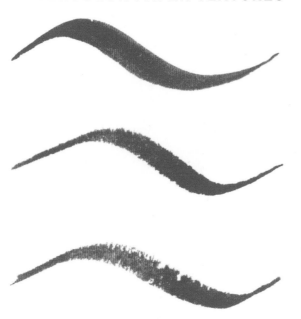

HOT-PRESSED PAPER This paper has been pressed with heat, which creates a smooth surface. Hot-pressed paper is ideal for fine detail, even washes, and a controlled style. This paper is not especially absorbent, which results in bright colors.

COLD-PRESSED PAPER Also referred to as "not" or "medium" paper, cold-pressed sheets are not treated with heat, leaving an irregular surface. This versatile paper is ideal for granular textures and a more painterly style.

ROUGH PAPER This paper is even rougher than a cold-pressed surface. The deep tooth can leave quite a bit of the paper showing along the edges and within each stroke. It complements an expressive style and drybrushing techniques (see page 17).

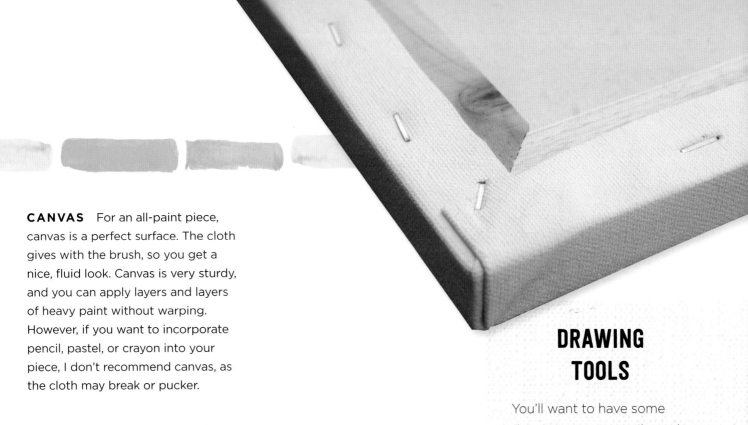

CANVAS For an all-paint piece, canvas is a perfect surface. The cloth gives with the brush, so you get a nice, fluid look. Canvas is very sturdy, and you can apply layers and layers of heavy paint without warping. However, if you want to incorporate pencil, pastel, or crayon into your piece, I don't recommend canvas, as the cloth may break or pucker.

DRAWING TOOLS

You'll want to have some drawing paper, pencils, and erasers on hand for making sketches before you start your paintings. I also like to incorporate pastels into my work sometimes, either in the sketch or on top of the dried paint. This is a fun way to combine media and experiment with mark-making and texture.

WOOD PANEL Wood panels are my go-to for acrylic paintings. They can handle layers of paint, while the hard surface is great for mixing in sharp pencil lines and other materials. Wood panels tend to be on the heavier side, in terms of hanging on a wall, but they are very durable. Like canvases, you can purchase them with a deep or thin depth. You can often purchase them already prepped with a layer of gesso, or you can use them raw. Shown here are several popular types of wood panels that you can find at hardware and art-supply stores.

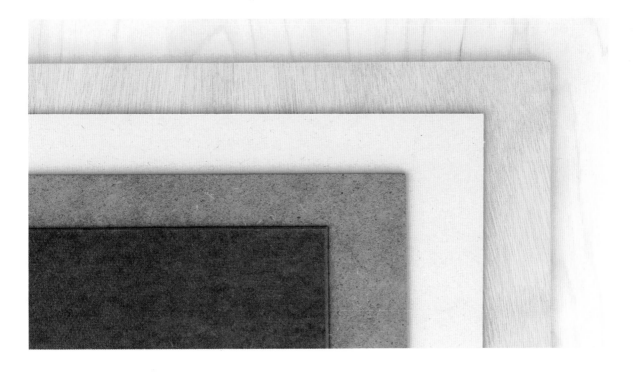

PAINTING BASICS

Because acrylic paint is water-based, it dries quickly. You can use this to your benefit by adding many layers to one piece in a short amount of time, without the colors mixing and getting muddy.

Another benefit of acrylic paint is that it doesn't require any chemical liquids to dilute—you just use water! You can take the thick paint that comes out of the tube and create any consistency between that and a watercolor-like paint, just based on the amount of water you add.

Here I've demonstrated a few different painting techniques that you can practice before you dive in!

WASHES Using a mop brush, water down some paint and practice creating washes of color. I usually dip the entire brush in my water glass first, and then mix that into the color. This will give you a watercolor-like consistency, with nice variation in color throughout the brushstroke, so you can see exactly how your brush moves. The faster you paint, the lighter the brushstroke; the slower, the more saturated the stroke will be.

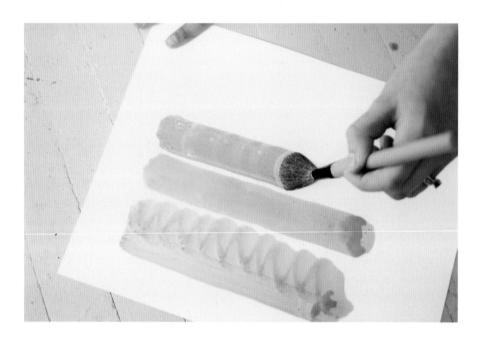

STIPPLING Stippling is a creative painting technique for creating texture or shading, as well as giving your piece an impressionistic look. You'll want to use a round brush, but choose the size based on how big you want your dots to be. Moving rapidly, create a bunch of little dots with the tip of your paintbrush. Allow the paintbrush to create subtle differences in the dots' sizes.

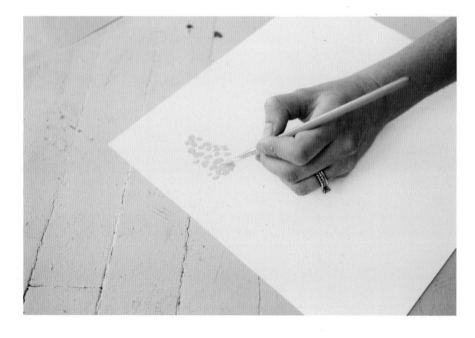

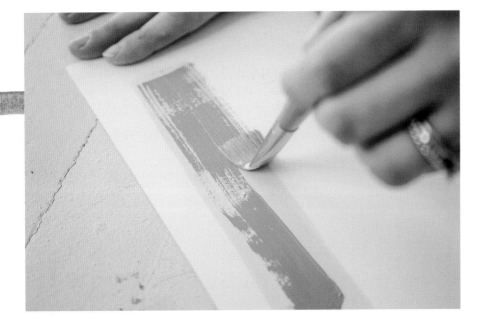

DRYBRUSH I often use this technique with contrasting colors. First lay down a thin layer of paint, or a wash of color. Allow that to dry, and then grab your flat paintbrush. Use a rag or paper towel to dry the bristles, and then load up the paint. Slowly drag the brush on top of the thin layer of paint, allowing the color beneath to peek through.

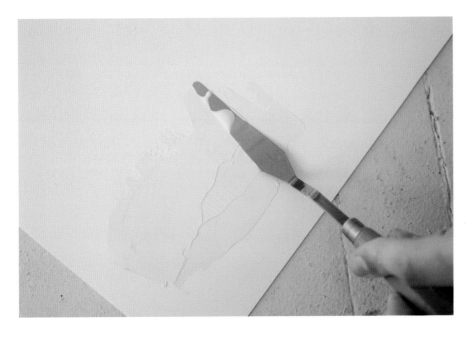

PALETTE KNIVES Palette knives are fun tools to play with. They create a thick yet smooth texture, unlike any other painting tool. You can even create full artworks with a palette knife! This gives the piece a very loose look, because you generally have less control than with a paintbrush. Play with letting layers dry before adding more, or mixing colors on your canvas instead of your palette.

SCRATCHING Another technique I often use in my paintings is scratching. When layering colors, use the handle of your paintbrush to scratch into the wet paint, revealing the color beneath.

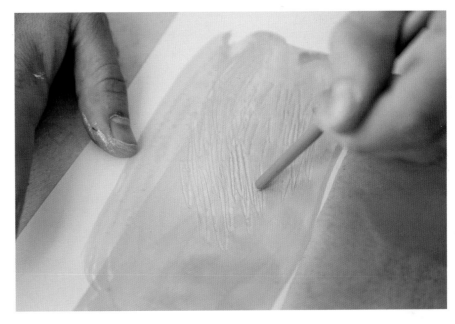

ADDITIONAL TECHNIQUES

There are myriad ways you can work with this versatile medium!
Here are several other techniques you might want to explore.

BLENDING To create a gradual blend of one color
into another, stroke the two different colors onto the
canvas horizontally, leaving a gap between them.
Continue to stroke horizontally, moving down with
each stroke to pull one color into the next. Retrace
your strokes where necessary to create a smooth blend
between colors.

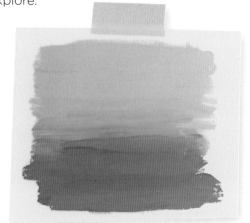

DABBING Load your brush with thick paint, and
then use press-and-lift motions to apply irregular dabs
of paint to your surface. For more depth, apply several
layers of dabbing, working from dark to light. Dabbing is
great for suggesting foliage and flowers.

SCUMBLING This technique refers to a light,
irregular layer of paint. Load a brush with a bit of slightly
thinned paint, and use a scrubbing motion to push paint
over your surface. When applying opaque pigments
over transparents, this technique creates depth.

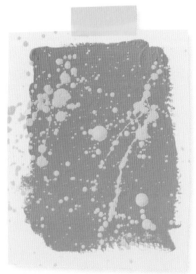

SPATTERING First cover any area that you don't want to spatter with a sheet of paper. Load your brush with thinned paint and tap it over a finger to fling droplets of paint onto the paper. You can also load your brush, and then run a fingertip over the bristles to create a spray.

SPONGING Applying paint by dabbing with a sponge can create interesting, spontaneous shapes. Layer multiple colors to suggest depth. Remember that you can also use sponges and thinned paint to apply flat washes.

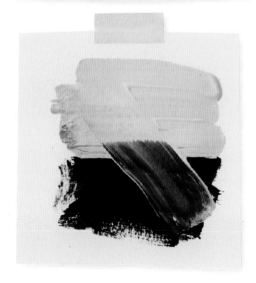

WIPING AWAY Use a soft rag or paper towel to wipe away wet paint from your canvas. You can use this technique to remove mistakes or to create a design within your work. Remember that staining pigments, such as permanent rose (at right with Naples yellow), will leave behind more color than nonstaining pigments.

& MARK-MAKING WITH PATTERNS

If you're new to painting, warm up with a few simple projects like the following patterns. These projects are perfect for experimenting with your brushes and mark-making tools and getting a feel for how the brush responds to pressure and the way you hold it in your hand. Bonus: Patterns make beautiful framed artwork or wrapping paper!

LINEAR PATTERN

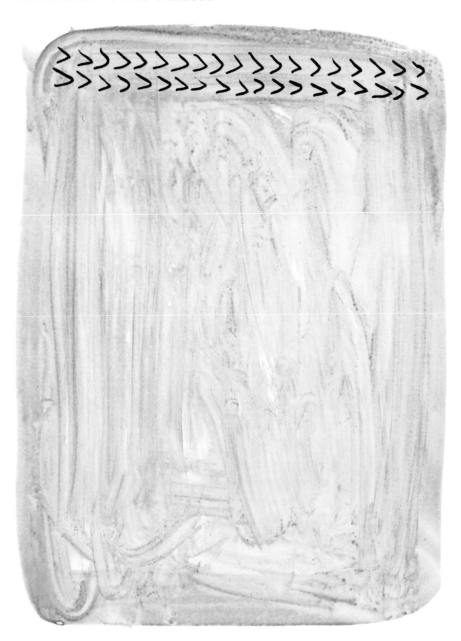

The simplest pattern is linear. Start with a medium gray for the background. For the first line, paint two simple rows of arrows pointing in one direction. I used watered-down ultramarine blue and a long, thin paintbrush to create sharp lines.

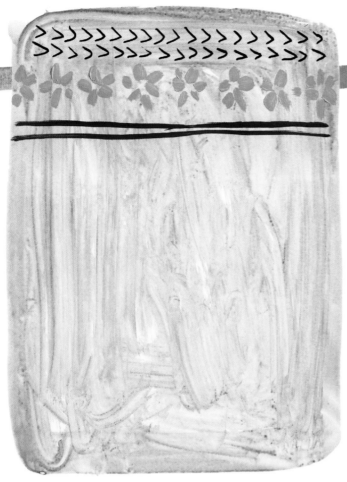

Add white to red to create a light blush color, and paint five simple flower shapes across the page. Then use dark green to paint two simple stripes below the flowers. This project explores different designs and lines—one line may be simple, while the next is more intricate.

With a wide paintbrush, apply a bright blue stroke across the page. Then use light gray paint and a filbert brush to create a block of loose dots.

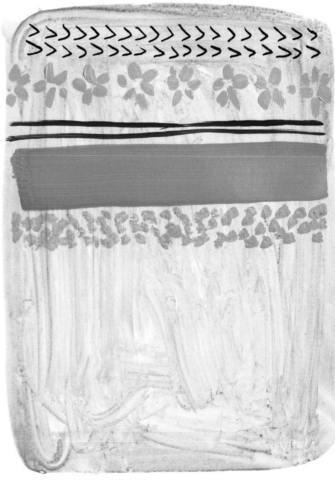

At this point, start to repeat to make a pattern. You can repeat the exact lines from the top down, or you can mix it up like I did. For the first repeated line, I used the same blue color as in the arrows at the top, but painted another row of flowers instead. Then I used the watered-down blush color to paint a wide, bold stripe across the page with my wide paintbrush.

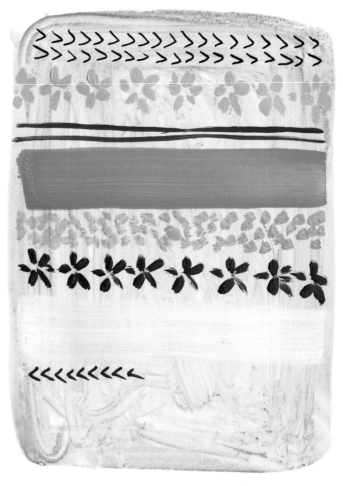

With a small paintbrush, use the same dark green from the stripes to make another two rows of arrows, but this time, point them in the opposite direction. Use the light gray for the thin stripes, and begin the block of dots with the bright blue from the original bold stripe.

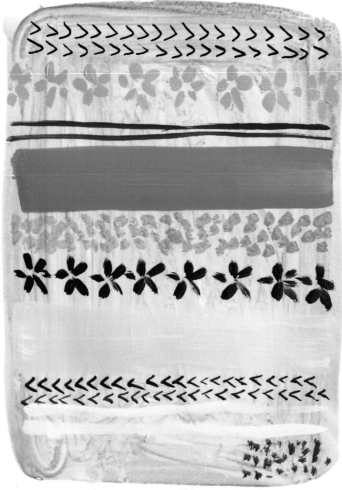

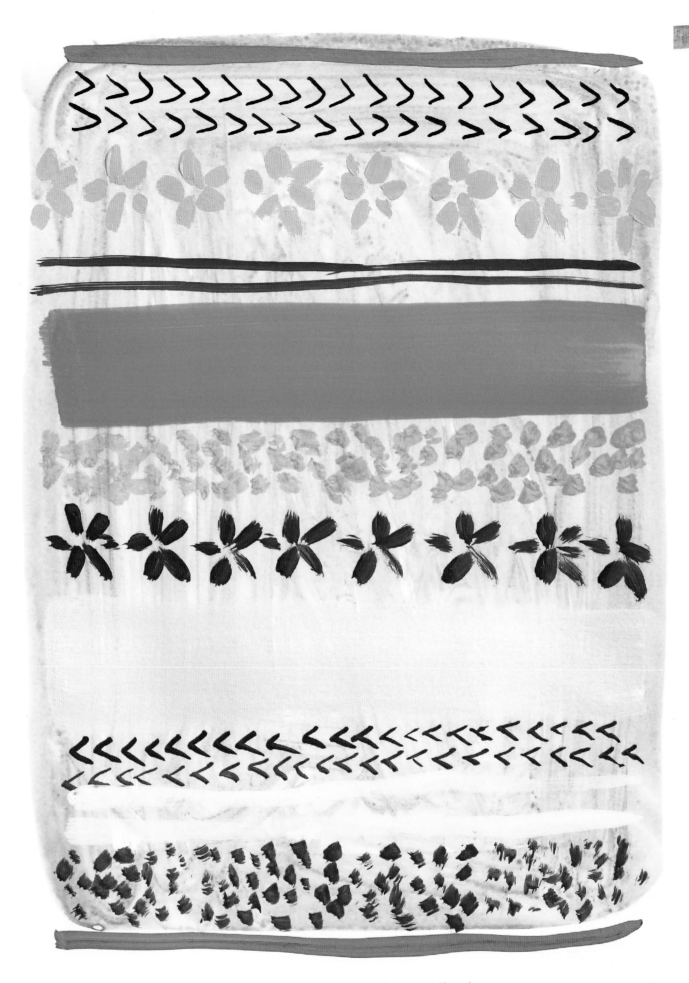

Finish by adding a thin blue line across the top and bottom to balance out the piece.

SQUARE PATTERN

To keep things simple for this pattern, choose just two colors: a background color and a light detail color. Paint the background with the darker color. I mixed green, blue, Payne's gray, and white to make this gray-aqua color. Evenly paint the whole background. Then, once dry, use a pencil and ruler to determine the size of your pattern squares and draw a grid over the whole paper. I made a four-inch grid.

Add a bunch of white paint to the leftover background mix to create a light color for the detail. You can also use another light color if you prefer more contrast. Start in one of the center squares, and create a design with edges that go over the pencil marks. As you can see, the center of my pattern is a small pair of flowers that bleeds over the pencil line at the top, with a heart-shaped leaf and another small pair of flowers that bleeds into the bottom of the grid.

Next, repeat the pattern in the two other squares in the center. Because you are painting this pattern by hand, the squares won't be perfect, but that's the fun part! You can make small adjustments to add uniqueness throughout.

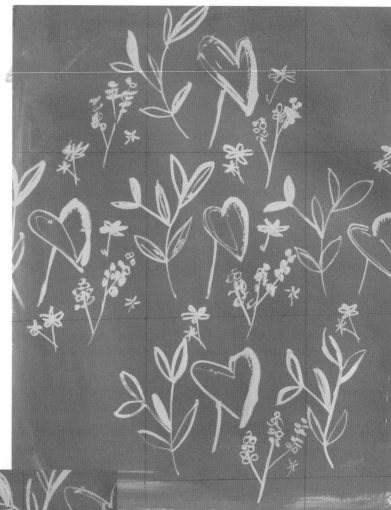

I find it easiest to fill one of the center horizontal grid lines, and then work on a vertical one. Then you have a block to work from as you move outward to fill in each square.

Fill the rest of the squares with the pattern.

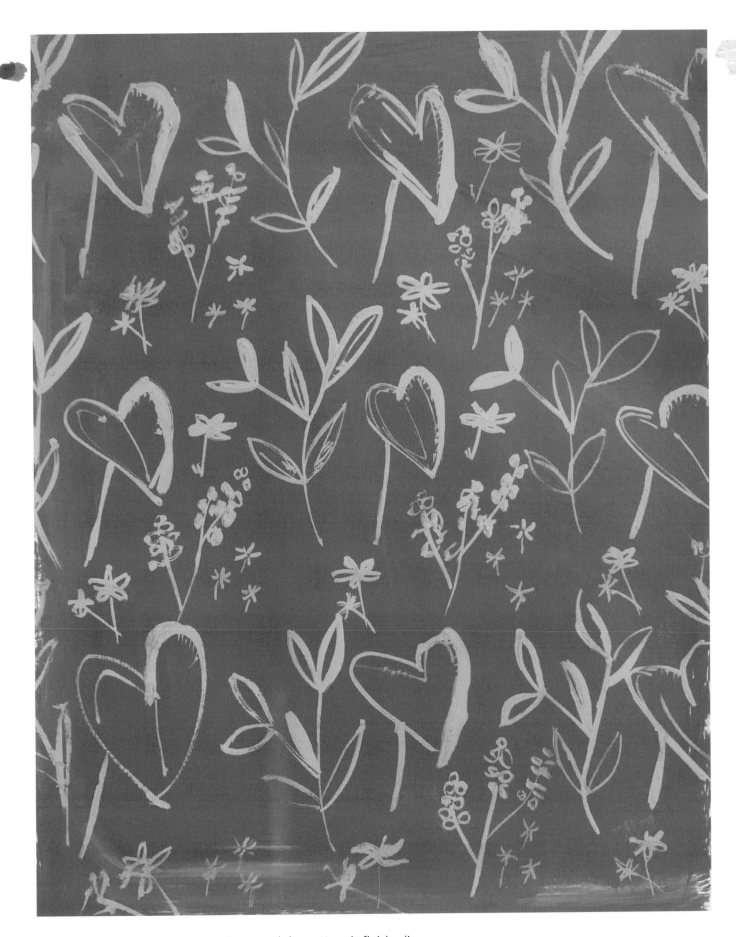

Go back and erase all your pencil lines, and the pattern is finished!

CLEANING UP

Cleanup is nice and easy with acrylic paint—just use soap and water! You should wash your brushes as soon as you're done painting. Dried acrylic paint is difficult to remove from a brush.

To wash your brushes, put some dish soap in the palm of your hand. Dish soap is generally mild, making it a good choice for this task. You don't need anything harsh to clean your brushes. If you like, you can also purchase artists' soaps and shampoos from an art-supply store.

With the water running, swirl the brush around in the soap in your hand. Press the bristles all the way down so you are cleaning every bit of the brush. You don't want to let dried paint build up where the bristles meet the wood, or the brush form will change.

Once all the paint is out of the brush, run it under clean water until all the soap is gone. If you see any paint remnants, repeat until the brush is completely clean.

Use your fingers to reshape the paintbrush before setting it aside to dry.

CLEANING YOUR PALETTE

If you opt to use a glass palette, you can easily scrape off dried acrylic paint with a razor. Just work carefully with the sharp blade. A plastic palette can be cleaned with soap and water. To clean a wood palette, scrape away the paint and wipe anything that remains with a soft, damp cloth.

ARTIST'S TIP

Always store your brushes flat or vertically, with the handle end down. Don't leave your brushes submerged in water between painting sessions.

EXPLORING
COLOR

COLOR THEORY
BASICS

Understanding the ideas and terms of color theory will help you develop a color palette for every painting project so that you can use color to your advantage to tell a story, set the mood, or emphasize a focal point.

THE COLOR WHEEL

The color wheel is a helpful tool for understanding colors and how they work together. Knowing where the colors lie on the wheel relative to one another can help you pair harmonious and contrasting colors to communicate mood or emphasize your message. The wheel can also help you mix colors.

Primary colors are red, blue, and yellow. With these three colors, you can mix almost any other color, but none of the primaries can be mixed from other colors. Secondary colors are green, orange, and violet. These colors can be mixed using two of the primaries.

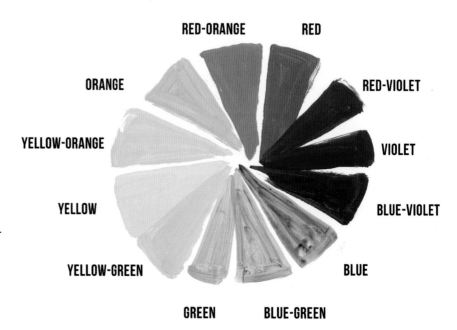

(Blue + Yellow = Green. Red + Yellow = Orange. Blue + Red = Violet.) Tertiary colors are created by combining a primary with a near secondary color, such as red with violet to make red-violet.

COMPLEMENTARY COLORS
Complementary colors are those situated opposite each other on the wheel, such as purple and yellow. Complements provide maximum color contrast.

ANALOGOUS COLORS
Analogous colors are groups of colors adjacent to one another on the color wheel, such as blue-green, green, and yellow-green. When used together, they create a sense of harmony.

TINTS, TONES & SHADES

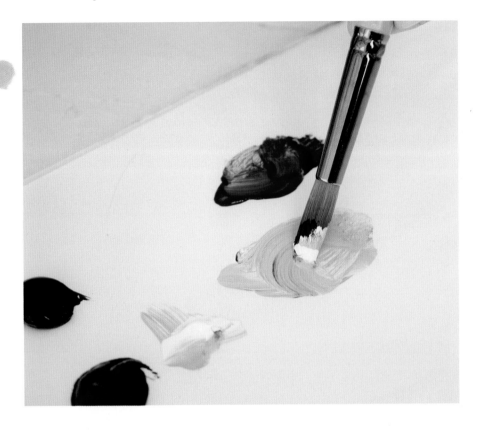

To practice mixing colors, start with white and choose one of your paint colors. Begin with the color in its pure form, and then slowly add white. As you add more and more white, you'll notice the paint getting lighter and lighter. This is called "a tint."

A tone or shade is created when you add black or gray to a color to create grayed versions of that color. Tones can be useful when thinking about shadows, or if you want a color to fade into the background. Imagine a painting with an elongated view or perspective—the tones of the foreground colors "push" the painting back and create the illusion of distance.

VALUE

Within each hue, you can achieve a range of values, from dark to light. Each hue has a value relative to the others on the color wheel. For example, yellow is the lightest color and violet is the darkest. Art-supply stores sell spinning, handheld color wheels that serve as mixing guides for painters. These wheels also show a range of gray values for reference.

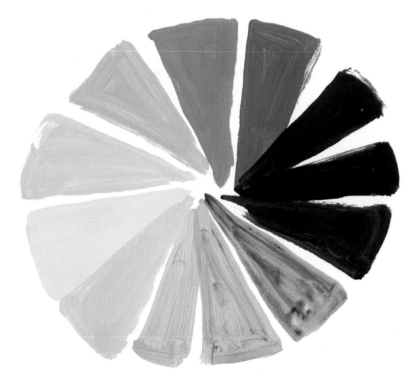

NEUTRALS

Neutral colors are browns and grays, both of which contain all three primary colors in varying proportions. Neutral colors are often dulled with white or black. Artists also use the word "neutralize" to describe the act of dulling a color by adding its complement.

COLOR TEMPERATURE

Color temperature refers to the feeling you get when viewing a color or set of colors. In general, yellows, oranges, and reds are considered warm. Greens, blues, and purples are considered cool.

When used in a painting, warm colors seem to advance toward the viewer, and cool colors seem to recede into the distance. This is an important dynamic to remember when suggesting depth or creating an area of focus in your painting.

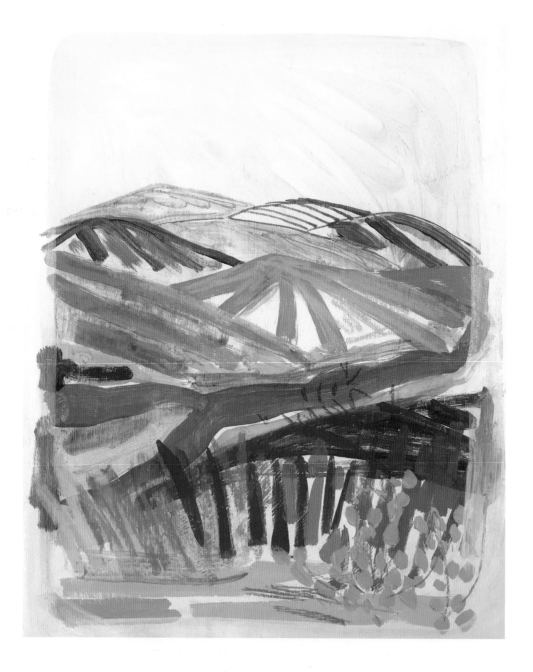

Note that even warm colors can sometimes lean cool, and vice versa. If a color leans toward red on the color wheel, it is warmer than a version of that color that leans blue. Shown here are cadmium yellow and lemon yellow. Cadmium yellow leans red and is warmer than lemon yellow, which leans blue and is therefore cooler.

USING COMPLEMENTARY COLORS

If you want a color to "pop," use contrasting colors to elevate the brightness of certain hues. Contrasting colors are also called "complementary colors." If you look at the color wheel, complementary colors lie directly across from one another (e.g., red/green, blue/orange, violet/yellow).

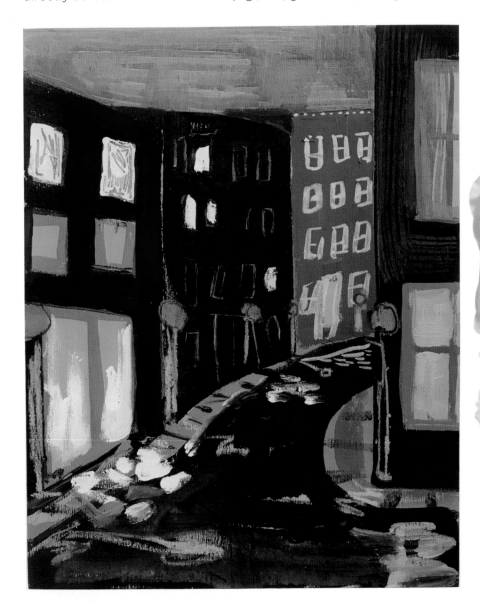

If I am painting a piece that will consist of a majority of blue tones, like this nighttime scene, I'll do an orange underpainting; the color subtly comes through and makes the blue "pop!"

ARTIST'S TIP

Combining complements is a great way to create accurate shadow tones. For instance, if you're painting a green leaf, combine some of your green with a bit of red (green's complement) to create a murky shade of brown that is a true shadow color for the leaf.

Complementary colors can also be used to dull each other. Shown here is pure cobalt blue (left) and cobalt blue with a dab of its complement, cadmium orange (right). The orange dulls, or neutralizes, the intensity of pure cobalt blue.

Another important way you can use contrasting colors is by mixing them to create a neutral. Yellow and purple are complementary colors; combined, they make a nice, neutral gray that works well with both colors in a painting.

SETTING UP
YOUR PALETTE

Before I begin painting, I like to set up my palette with all my main colors. I am left-handed, so I set up my palette with the empty space for mixing on the left side. If you are right-handed, you'll want to set it up with empty space on the right side.

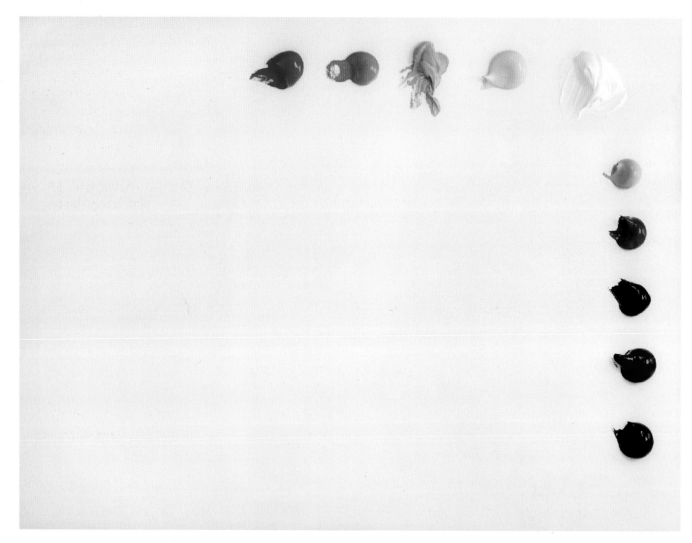

ARTIST'S TIP

I encourage all beginners to spend time playing with color. See how your favorite colors look on different backgrounds, black versus white, a similar color versus a contrasting color, etc.

First I place a large glob of white paint in the top right corner (right-handers, put yours in the top left corner!). At the top, I put all my warm colors, from left to right: cadmium red, orange, yellow ochre, and cadmium yellow. Then I place all my cool colors down the side, from top to bottom: permanent light green, green oxide, ultramarine blue, cobalt blue, and Payne's gray.

I've found that this combination of colors allows me to create almost every shade of every color.

If you find that you are drawn to a certain color palette, feel free to purchase paint in that color. If you aren't sure, these are great colors to begin with!

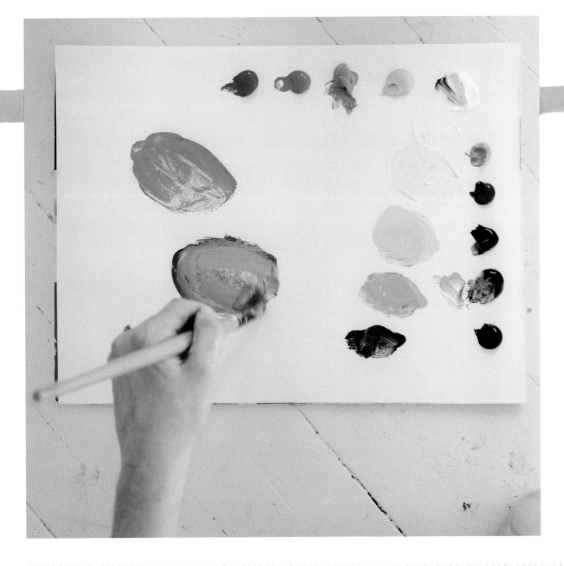

Use the open area on your palette to mix colors. With this limited palette, you can create an endless array of color mixes—the sky is the limit! You might want to keep a notebook where you can record your notes about color mixes you like, so you can create them again for future projects!

TIPS FOR COLOR MIXING

- Make your color mixes a shade or two lighter than the desired final hue. Paint dries slightly darker than it appears on your palette. If you're not sure about a color you've mixed, smudge a little bit on a spare sheet of paper to see how it looks once dry.

- Add dark to light. You need only a little bit of dark paint to alter a lighter color, and you need a lot more of a light color to alter a dark color. This will help make your paints last longer!

- Use small amounts of paint as you mix. You can always add more of a color if you need to, but you can't take it back out! A little can go a long way.

- Mix more than you think you need. It can be difficult to create exactly the same mix if you run out of the hue while you're in the middle of a painting project!

- Don't discard your leftover mixed paints. You can store them in airtight containers to use again later.

- The more you paint, the easier color mixing will become, as you grow familiar with the properties of each color on your palette.

BEGINNING
PAINTING

SKETCHING

Most painters begin a new painting with a light sketch. A sketch helps you ensure that you've got the right proportions, perspective, and composition before you start painting. It's an important step that saves time and materials.

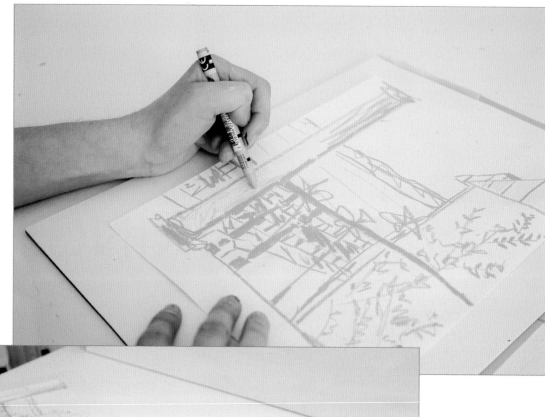

Make sketching the first step for all of your painting projects. There are a few ways to approach this step. You can sketch on a separate piece of drawing paper that you refer to as you paint. You can also sketch directly on your final surface with light pencil lines, or you can even make your sketch with a brush and paint. Sometimes I use pastels or colored pencils to make the initial sketches on my final surface.

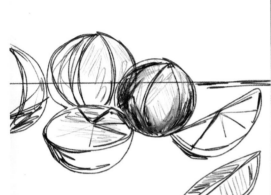

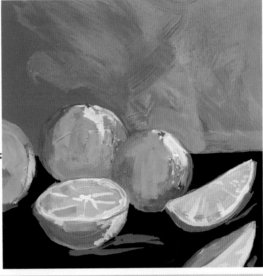

I sketched this still life scene of oranges on paper first. You can see how I used rough lines to indicate areas of shadow. When I was ready to paint, I used my sketch as a reference to create an underpainting of the oranges with yellow ochre on my final surface.

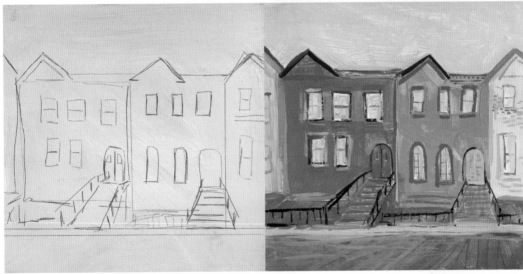

Architecture, in particular, can be difficult to get right. I always sketch these types of scenes first on the actual surface—in this case, a square canvas.

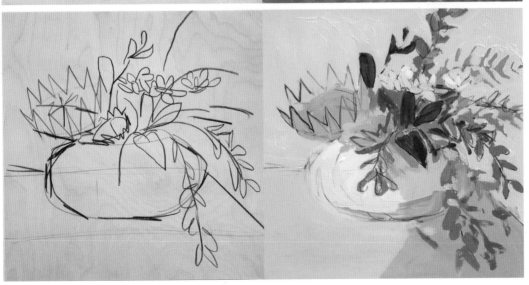

You can also incorporate your sketch into the final painting by using a bold colored pencil. Here, I used cobalt blue for the sketch, which contrasts with the more neutral tones in the finished painting.

UNDERSTANDING PERSPECTIVE

You don't have to be great at drawing to make your initial sketches, but it is helpful to have a general understanding of a few drawing concepts. One of the most important is perspective. Perspective is how you represent a three-dimensional subject on a two-dimensional surface—your paper, canvas, or wood panel—so that it reflects reality. With proper perspective in your artwork, you can create the illusion of depth and distance.

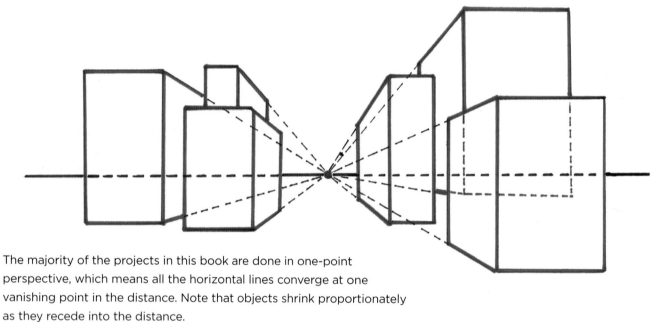

The majority of the projects in this book are done in one-point perspective, which means all the horizontal lines converge at one vanishing point in the distance. Note that objects shrink proportionately as they recede into the distance.

In this scene, the horizontal lines meet at the horizon line. Establishing the vanishing point in the beginning will help you work out the correct angle for any lines that come toward or move away from the viewer.

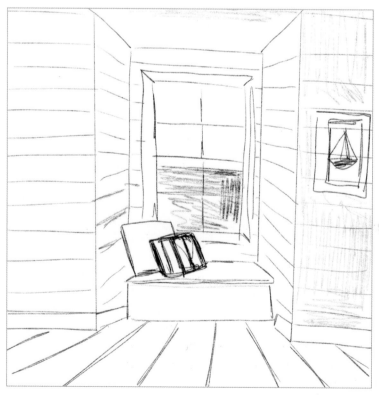

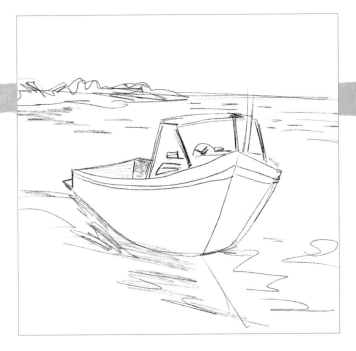

Foreshortening is a perspective technique that creates the illusion of an object receding strongly into the background so that it appears shorter than it is in reality. See how the boat in this sketch looks compressed? The foreground lines for the front of the boat are at maximum size, and they appear increasingly shorter as they rotate away from the viewer. This simple technique creates depth and dimension in the boat.

The horizon line is a horizontal line that describes the separation between sky and land from the viewer's eye level. Often, the horizon line is in the middle of the scene. In this sketch, the horizon line is in the upper third of the scene, which implies the vast stretch of ocean receding into the background.

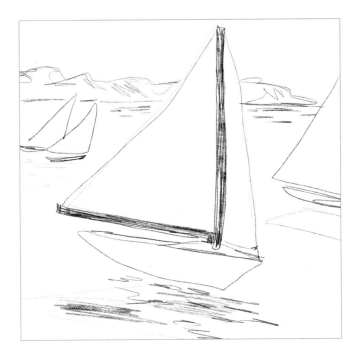

ARTIST'S TIP

Don't stress out over perspective and spend hours figuring out the angles. With just a few minutes of time, you can see and identify the basic angles and roughly block them out. You might even use a ruler to help achieve straight lines. And if you're working somewhat abstractly or impressionistically, you don't need to be a slave to completely accurate perspective.

Remember that objects will appear smaller, or diminish in size, as their distance from the viewer increases. This is called "diminution." In this sketch, the foreground sailboat, which is the focal point, is large. The portion of the boat visible in the middle ground is smaller, and the two distant sailboats are even smaller.

ATMOSPHERIC PERSPECTIVE

Atmospheric perspective is another important part of art, especially for painters! Atmospheric perspective is crucial in creating the illusion of depth and dimension because it's responsible for the way objects in our field of vision appear to change in size, color, texture, focus, and brightness as they recede into the distance.

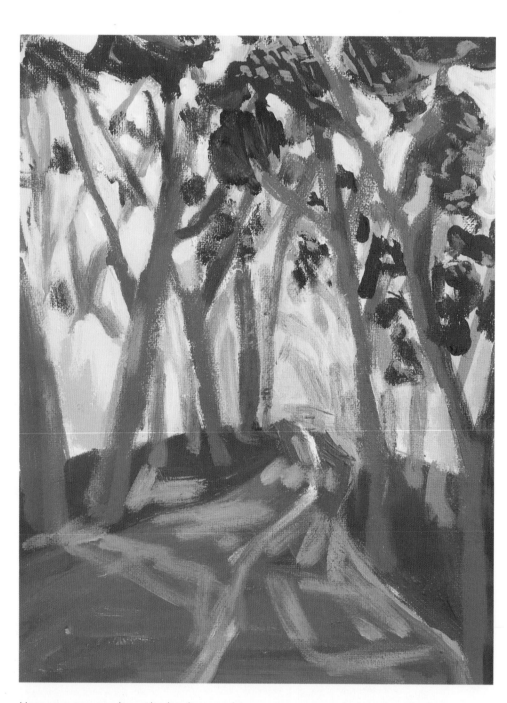

ARTIST'S TIP

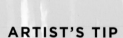

When applying atmospheric perspective, remember to paint distant objects with less detail, and use cooler and/or more muted colors. In the foreground, apply more detail and use warmer, brighter colors.

Here you can see how the background trees are more muted and cooler in tone than the foreground trees. The bluer tones help "push" them back and create the illusion of distance. The green foliage in the foreground trees is also much brighter.

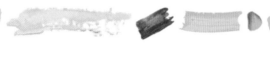

This is a great example of atmospheric perspective, because even though it's very abstract, the application of color still creates the illusion of depth and distance. Against the cool blue and green mountains and valley in the background, the bright, warm flowers and foliage in the foreground seem to "pop" forward.

Background

Middle ground

Foreground

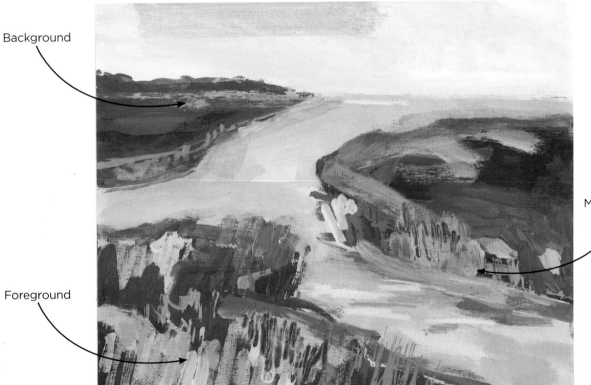

In this scene, you can see how the use of detail helps create atmospheric perspective, even without a razor-sharp, realistic painting approach. Notice how the foreground foliage, while abstract, is much more detailed than the middle-ground foliage, and even less so than the distant foliage, which is really nothing more than suggestive strokes.

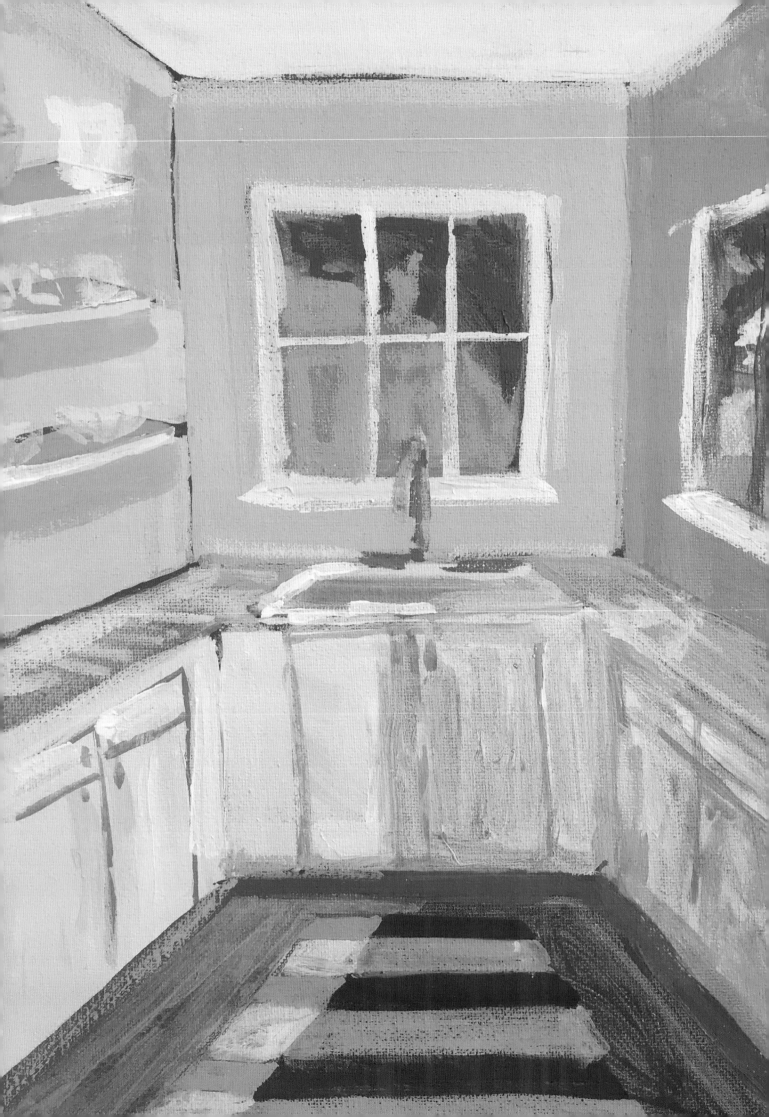

PAINTING
EVERYDAY LIFE

INTERIOR SCENES

Painting interior scenes can be tricky because they usually involve some perspective, which refers to when you can see your scene receding into the distance. These simple scenes employ one-point perspective, which means everything recedes to one point in the distance along the horizon line, which is usually at eye level. For more on perspective, see pages 42–43.

FRENCH DOORS

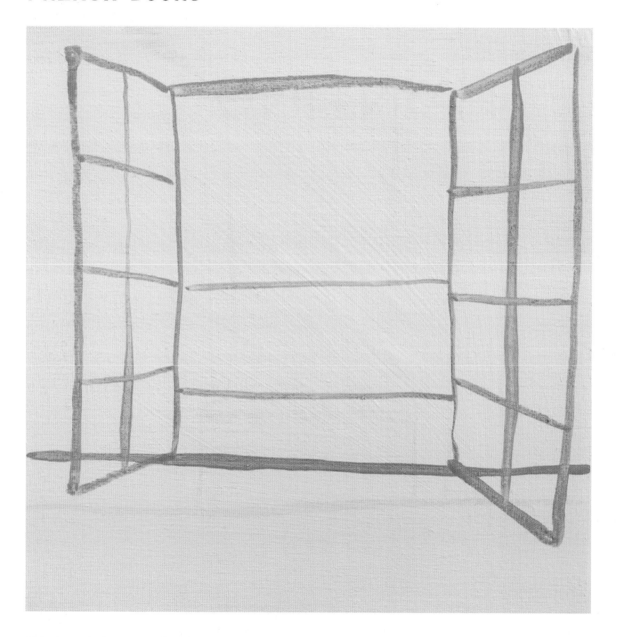

Start by painting a wood panel or canvas white with a large paintbrush. With a rigger paintbrush, water down your paint, and loosely sketch the scene on the dry surface. You can use any color you like!

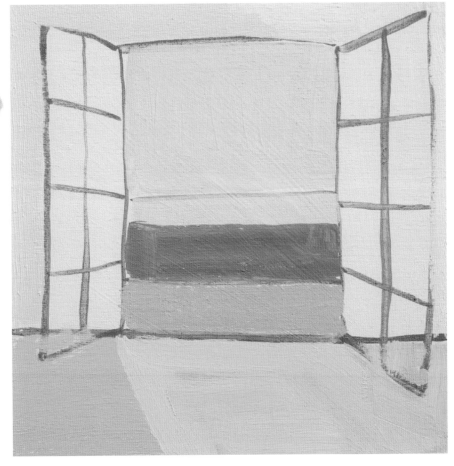

Pick a direction from where the light source comes. In my painting, the sun is the main source of light, and it's coming from the left side of the outdoor space. With the light source in mind, block in the colors with a flat paintbrush, generally shaping the piece. In my scene, the darkest parts are on the left (where the light source is located), and the lightest parts are on the right, where the light hits.

For the walls, take a medium pink paint, and create a lighter tone and a darker tone. Use the light tone on the right side, where the bright sun hits. Add the dark tone to the left side. Begin to add details to the scene, such as the balcony railing.

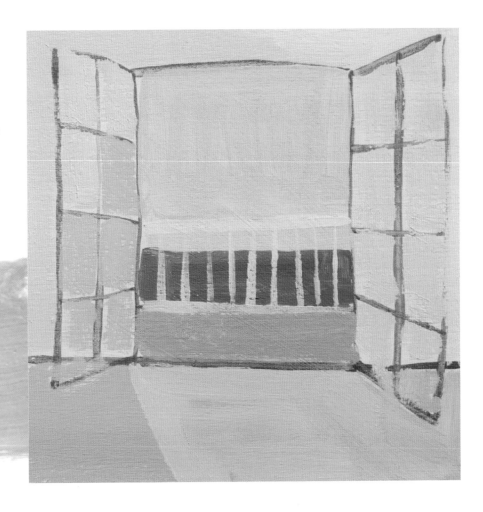

ARTIST'S TIP

You could paint these pretty French doors closed as well, but I love the look of these open doors beckoning the viewer into the scene!

Use yellow or another bright color to accentuate the most forward parts of the space.

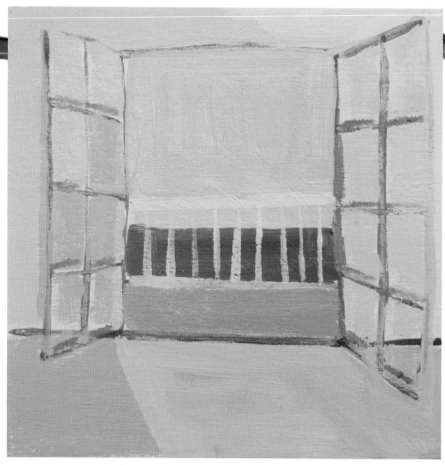

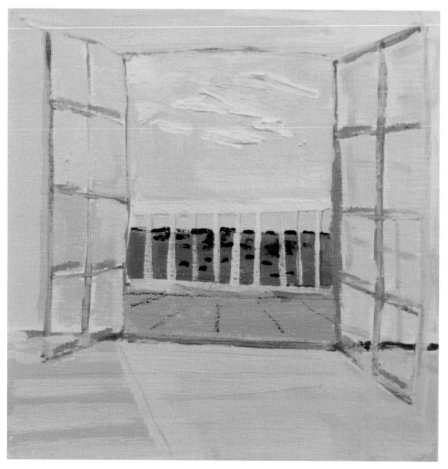

With light and perspective in mind, add a pattern to the floors. Loosely add chunky paint to the sky to suggest clouds. Apply a dark blue line to push the horizon line far into the distance, and then add dashes to bring the ocean gradually forward. Finally, add a faint shadow of the French doors on the right side of the painting.

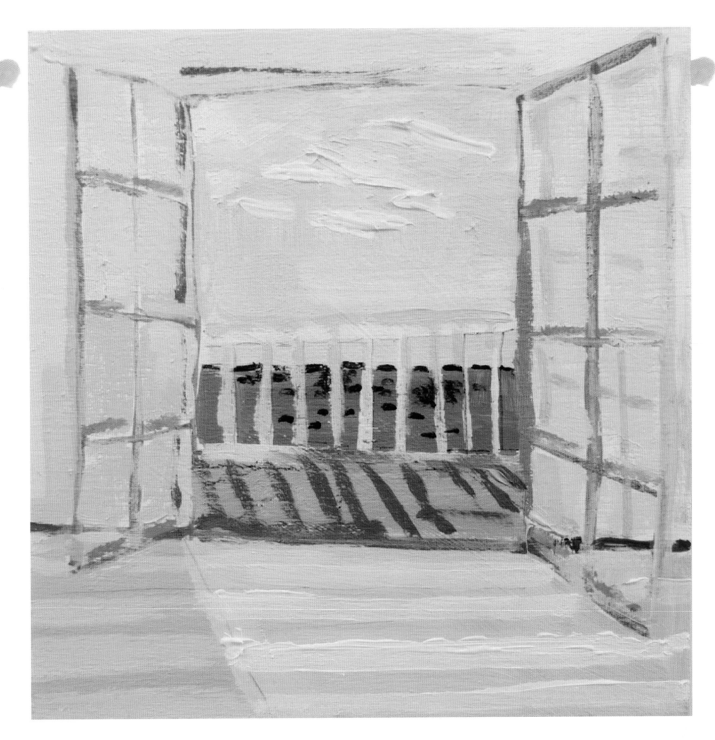

Add the most drastic shadow to the outdoor balcony, and use a warm color to add detail to the balcony, which suggests sunlight hitting it. Finally, sharpen any details with fun pops of color!

COZY WINDOW NOOK

First, cover the canvas with white paint to create a nice base. Once dry, use diluted ochre to outline the detail of the room. Make sure you are thinking about perspective, as these lines will guide the rest of the painting. You might find it helpful to make a light pencil sketch first.

Mix pink and orange to create a dark peach color, and block in the walls farthest from the window. Then add some white paint to the peach mix, and block in the wall right around the window and the left diagonal wall. Add even more white to lighten the color again, and block in the right diagonal wall and ceiling.

The dark peach walls appear to advance, while the light peach appears to recede, achieving perspective in the scene.

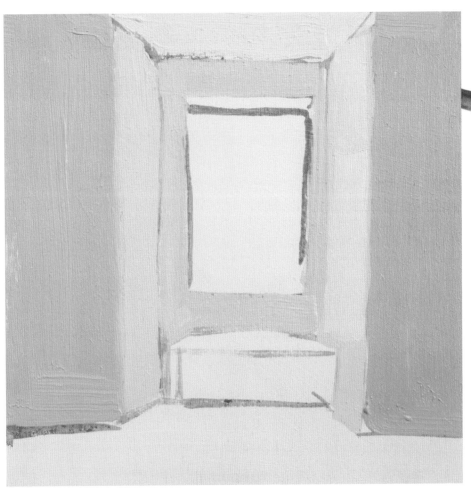

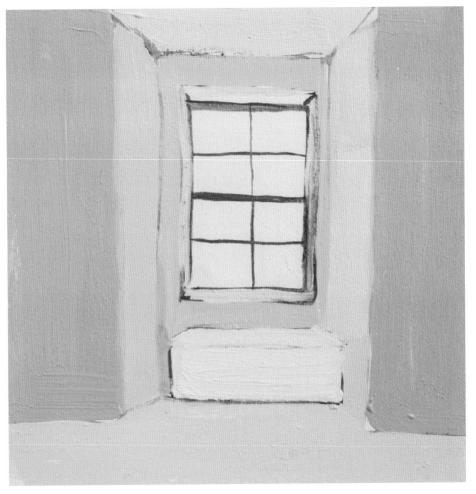

Use pure white to block in the window seat and the molding around the window. Add a touch of Payne's gray to white to create a pale gray color for the floor. Use turquoise to define the window frame and panes, as well as to add a bit of dimension to the window seat.

Contrast the peach walls with a nice turquoise for the water outside the window. To bring that color throughout the painting, add turquoise to the top of the window seat and a darker turquoise stripe at the bottom.

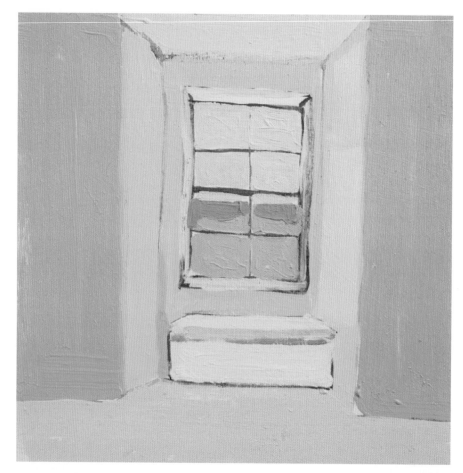

With a thin flat brush or a rigger brush, use ochre to add lines on the walls to mimic shiplap. The front flat walls should have straight lines, while the lines in the nook should angle to create the proper perspective. Connect the angled lines with straight lines at the very back wall around the window. Focus on perspective while doing the panels on the floor as well. Notice how my lines slightly angle inward, pointing toward the invisible vanishing point.

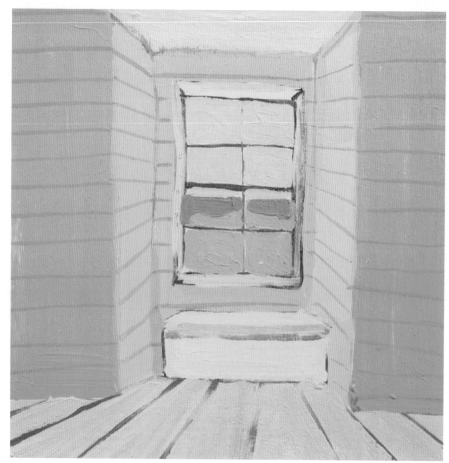

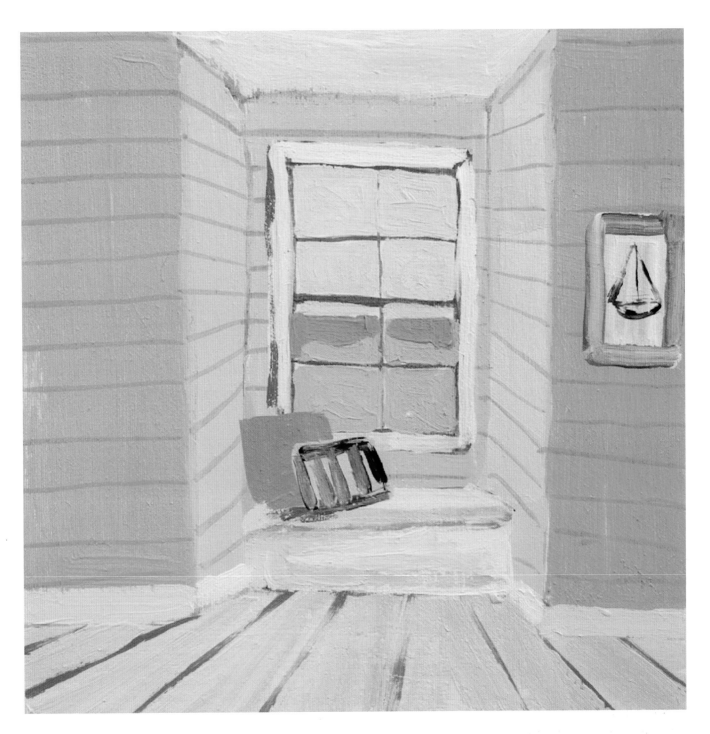

Add a cozy feeling by roughly blocking in a couple of pillows and adding a small painting on the wall.

KITCHEN

Start with a sketch, focusing on perspective. Use a ruler to get nice, straight lines so that the room looks like it's coming toward you.

Imitate your sketch with paint on the canvas to begin building the composition and structure of the painting. I don't use a ruler for this part, because I think the loose lines are more inviting. Think about the light source as you fill in the wall color. My main light source is from the right window. Mix three shades of peach for the wall by mixing yellow, red, and white. Then use the midtone color on the wall straight ahead, the lightest tone on the left wall, and the darkest tone on the right wall.

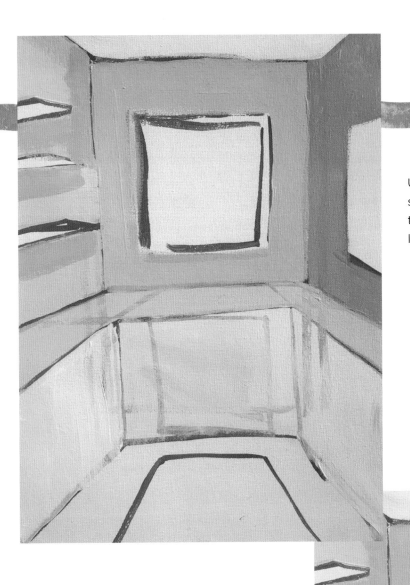

Use the darker peach color to add shadows to the open shelving, and then wash some white onto the lower cabinets.

Begin to wash more color into the painting to cover the entire canvas. I use light ochre on the countertops, dusty blue in the windows, and green on the floor and in the windows to suggest trees.

Wash another layer of color on the countertops. Add a clean line on the end of each shelf, and use a darker color on the tops. With a small paintbrush, use that same color to outline the drawers and cabinets. Then outline the window frames with white and paint the panes on the far window.

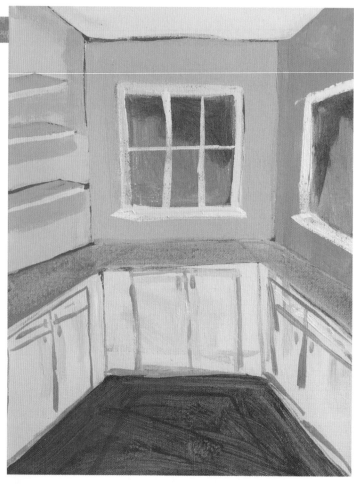

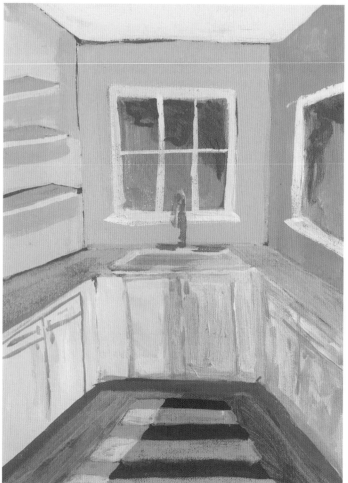

Next, spend some time detailing the sink. I use white for the edge, and then wash in light gray to create depth. Add a fun rug on the floor. Now that most of the details are finished, refine the lighting by washing in more colors. For instance, I mix a green-gray wash to darken the cabinets on the right side, which are in shadow. The contrast of light to dark is made very evident in the rug, which is mostly in the dark, with one edge lit up where the sun hits.

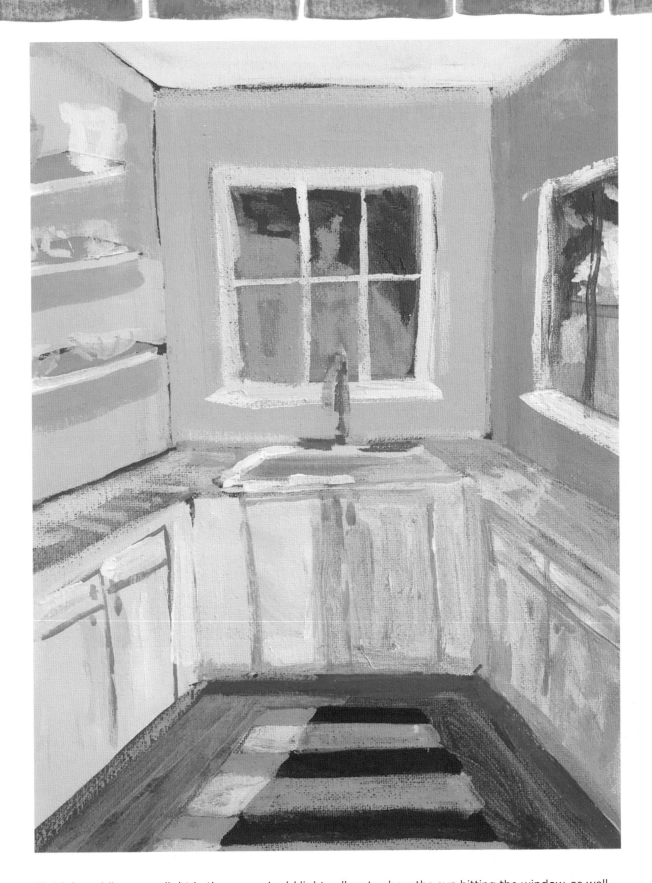

Finish by adding more light in the scene. I add light yellow to show the sun hitting the window, as well as some bright splashes of color outside. Add some bright kitchen pieces to the shelves. You don't need to worry about detail—a few simple shapes and lines easily suggest bowls, pitchers, and so on. I also add a pure white edge on the sink to create even more definition and highlights.

LIBRARY

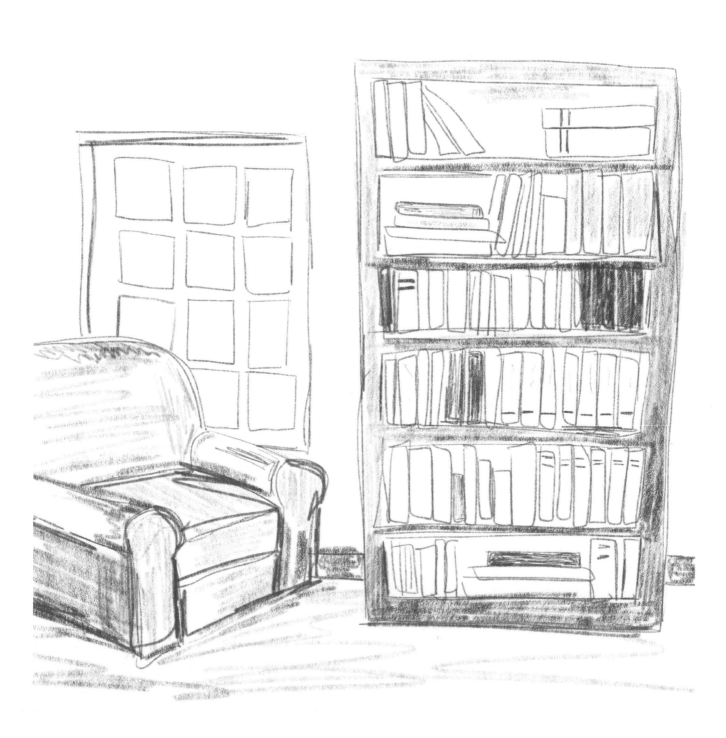

Sketch out your ideas and think about the shapes of the
furniture in the room and how each piece takes up space. If you
like, you can use a piece of tracing paper to trace my sketch!

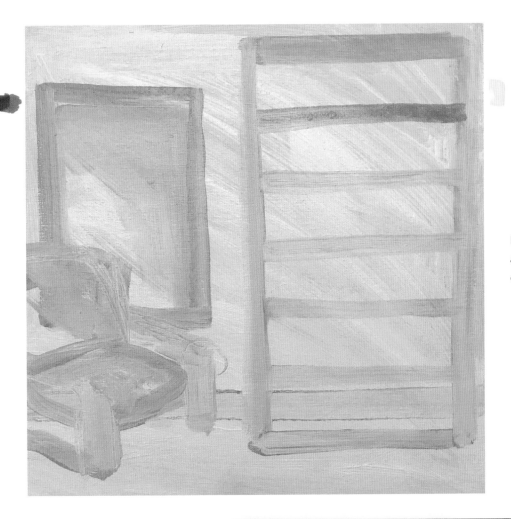

Referring to the sketch, create an underpainting in yellow ochre on the canvas.

Block in the back wall in the color of your choice—I used navy blue—and then mix gray and navy together to create a neutral gray for the floor. Then begin shaping the leather armchair.

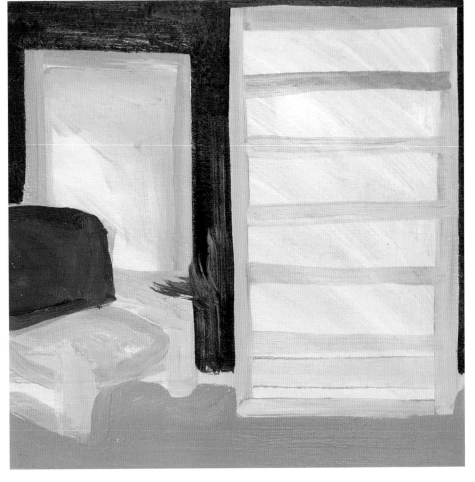

The back of the bookcase should be darker than the front since it recedes into the background, so block it in with dark brown before you begin painting the books. I use the same brown as the armchair to create unity in the painting. Use pure white to paint the window frame.

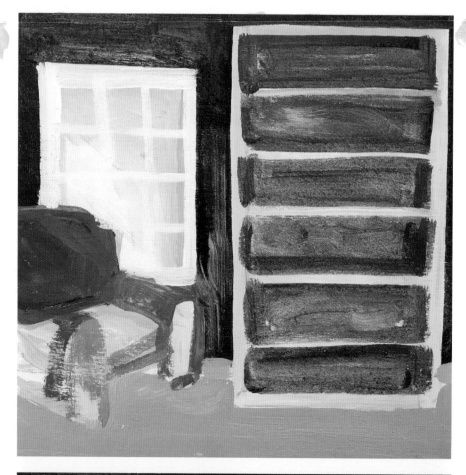

Start to add books, making the heights, widths, colors, and designs different. I mix the gray color I used on the floor and the navy from the wall for the colors. Mixing all the colors you've already used to create new tones is a great way to unify the painting and create flow. Fill in the window with the same blues.

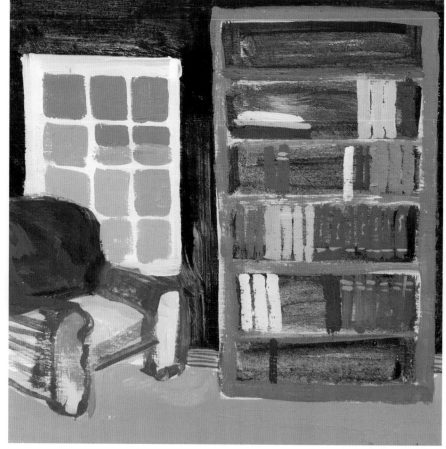

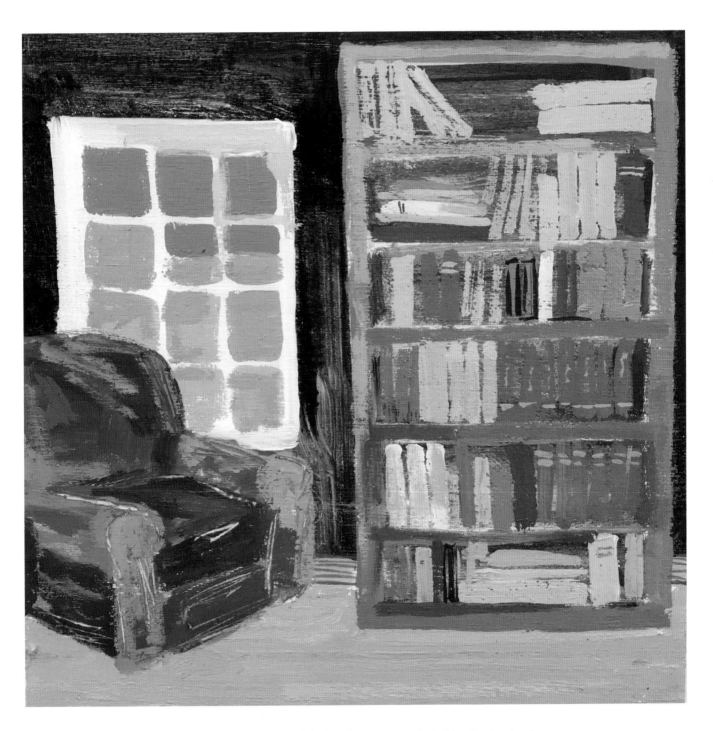

Think about the light from the window as you finish shaping the armchair. Use the back of your paintbrush to scratch in some of the edges of the chair. Add marks in the window to create dimension, using the neutral tones you used for the floor and bookcase.

PICKUP TRUCK

A great technique for emphasizing your focal point is to use highly diluted paint in the background. The soft watercolor-like background allows the detail of the subject matter to stand out.

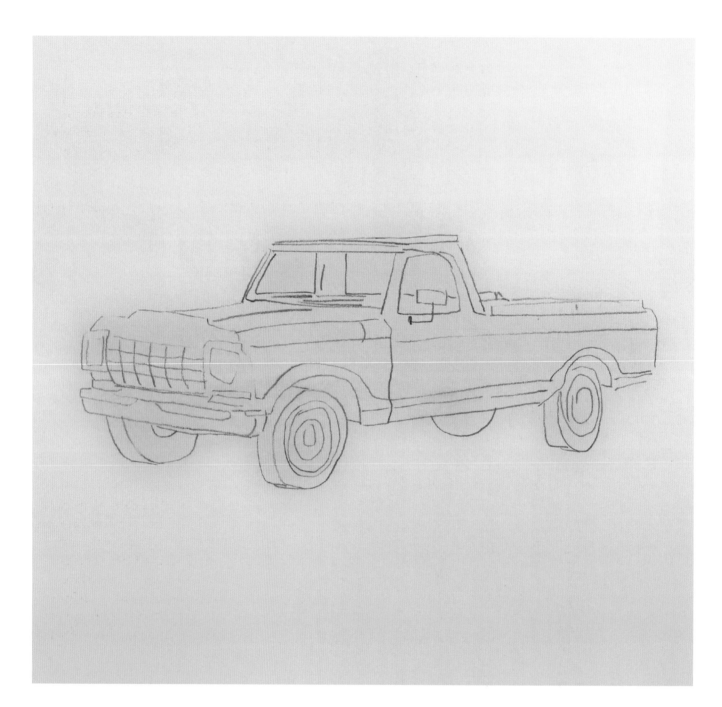

Study a truck in real life, or use a reference photograph to sketch the details you'd like to capture. If you're using a photograph and want a realistic look, you can use tracing paper to get the structure correct. When you're happy with the sketch, transfer it to your final surface.

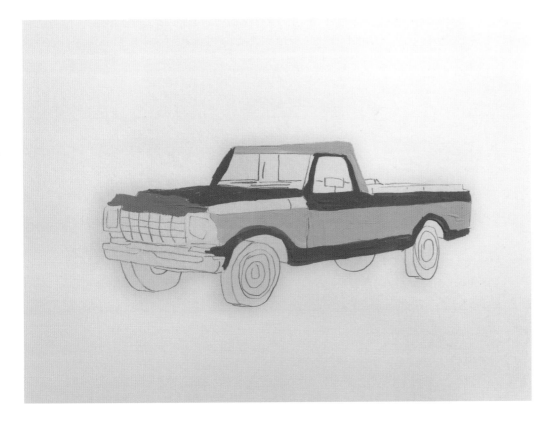

Start to work in the color, beginning with darker tones and then adding lighter tones. Try to follow the direction of the object with your paint strokes.

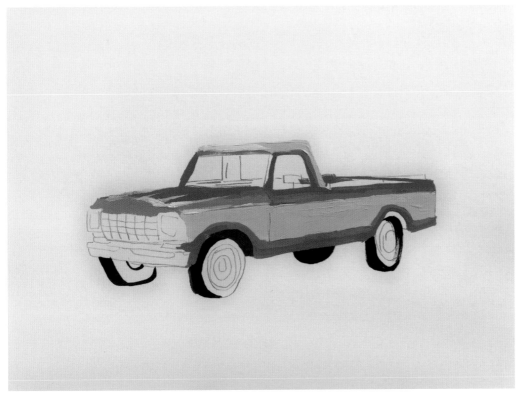

Use your reference to try to match the truck colors as you paint. Use black to fill the outline of the tires, and use light paint on the hood and top of the truck to shape it.

Use black to fill in the rest of the tires and the front of the grill. Then use dark brown to paint the interior of the truck with minimal detail.

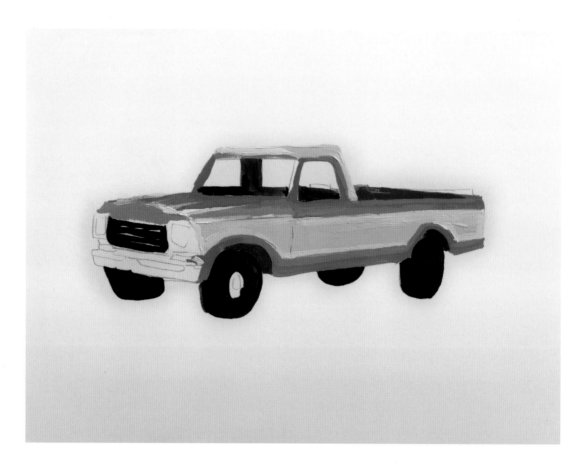

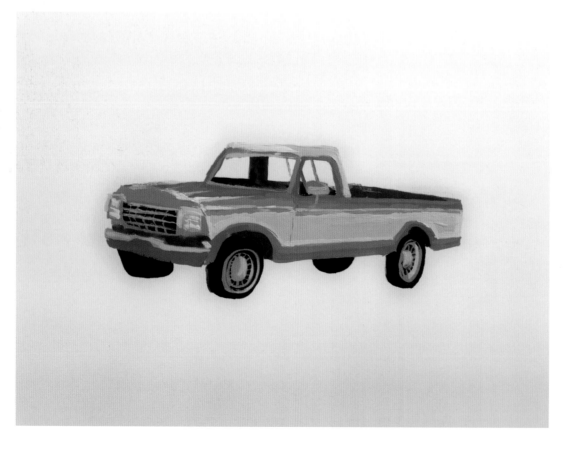

Use gray paint to finish the grill and fill in the tire rims and metallic details on the truck. Use tiny paintbrushes to clean up the outside lines of the truck.

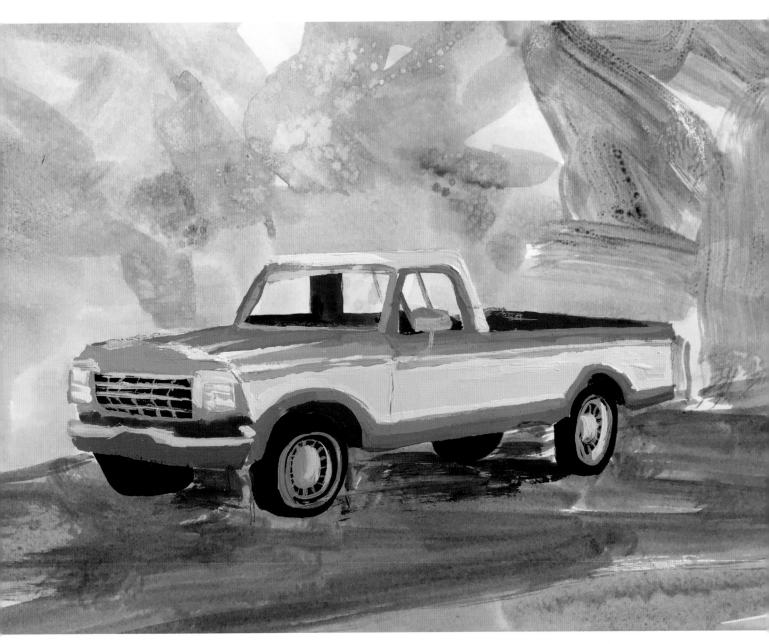

Finally, add a washy background and road behind the truck. Water down the colors so they resemble watercolor paint. The soft, blurred background allows the detailed acrylic truck to stand out.

 ORANGE
STILL LIFE

For this still life of oranges, let's use a bold complementary color scheme that is vivid and full of contrast. I painted this on a birch wood panel, but you can use canvas or canvas paper if you prefer.

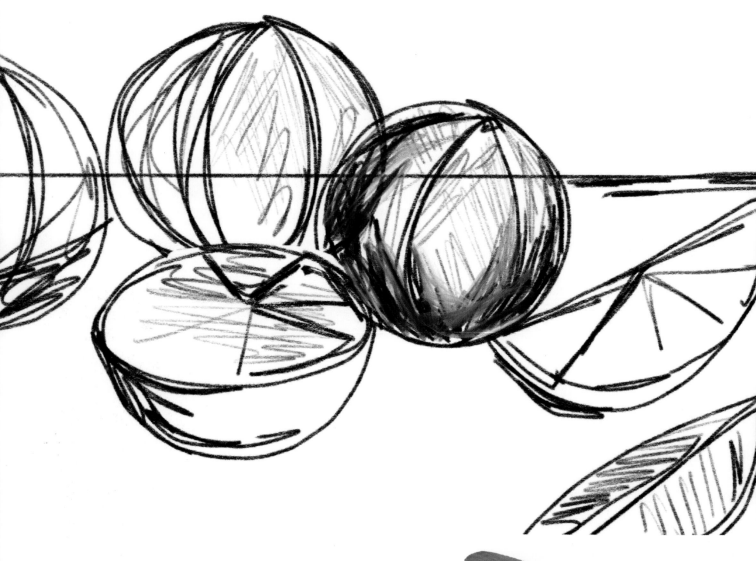

Start with a sketch from life to build the shapes and help you determine the shadows and highlights.

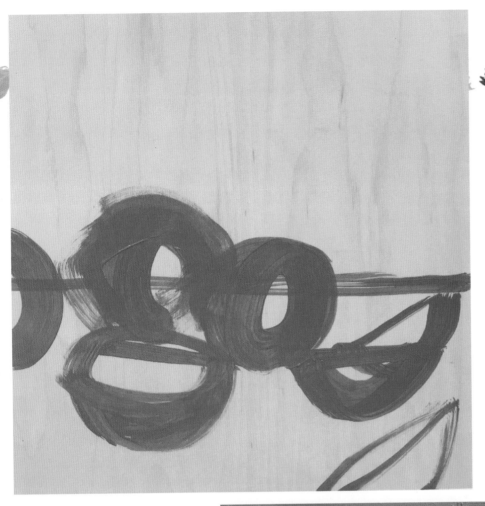

On a birch wood panel, use yellow ochre to create an underpainting of the oranges from the sketch.

Using ultramarine blue and Payne's gray, mix navy blue to paint the table—this color will make the orange look even brighter. Then add white to lighten the navy and fill in the back wall.

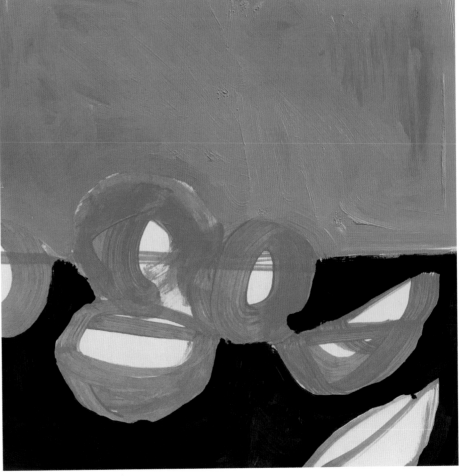

Use a medium orange color to work on the shapes of each orange. I used a flat paintbrush so that you can see the paint strokes, which help define the curves of the circular fruit.

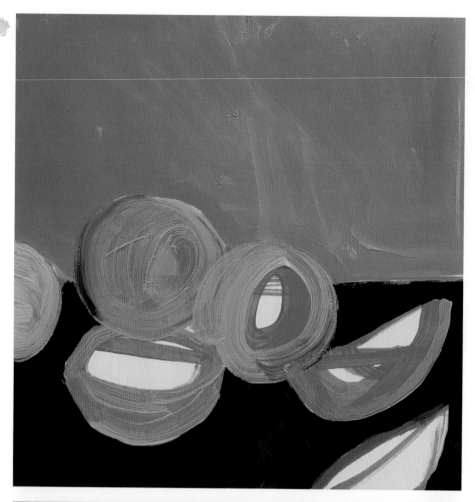

Add white to the medium orange paint, and fill the insides of the cut oranges. Take a tiny dab of light orange and mix it with white to create the lightest shade of orange you can—almost white! Use a small filbert paintbrush to add reflections on the rinds of the whole oranges and to paint the membranes in the cut oranges.

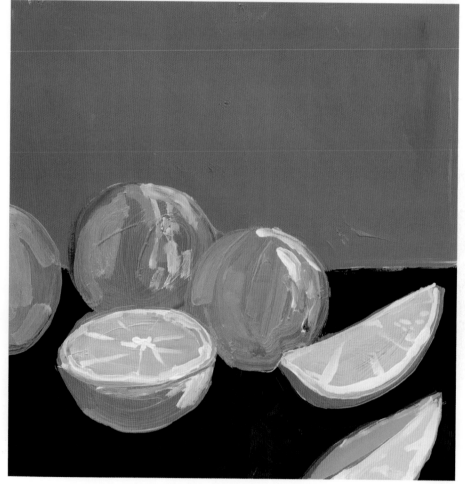

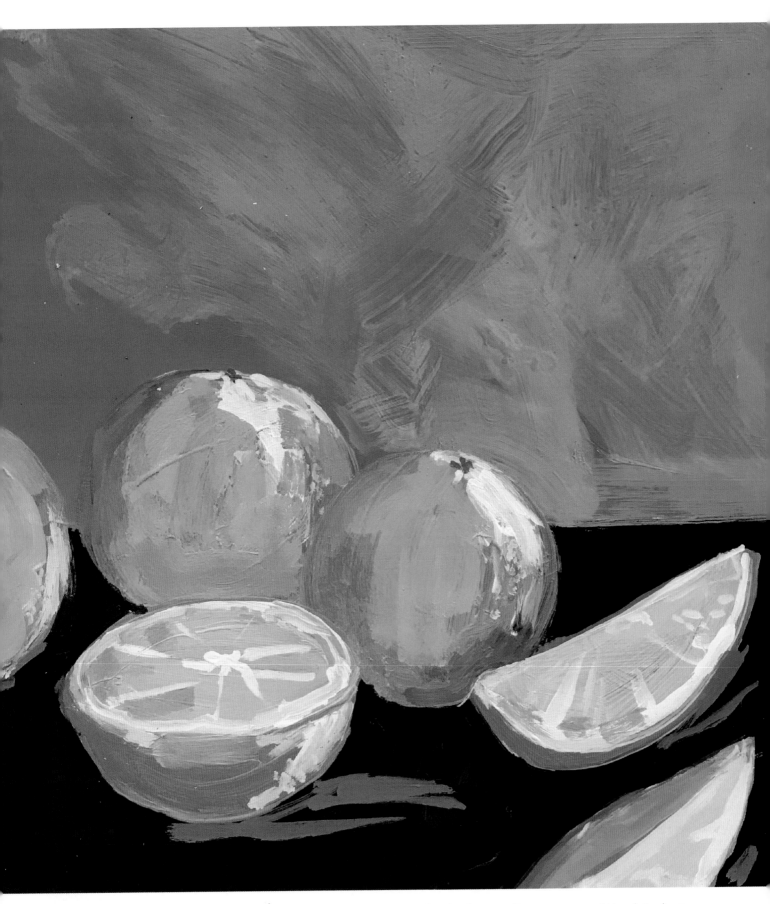

Mix some navy with the orange and paint the shadows on the oranges and the dot where the stem once was. Use this color to roughly block in the cast shadows the oranges make on the table as well. With a stippling technique, use the lightest orange to create texture on the orange rinds. Finally, do a wash of white on the background wall to show the light moving from one side to the other, making the right side brighter than the left side.

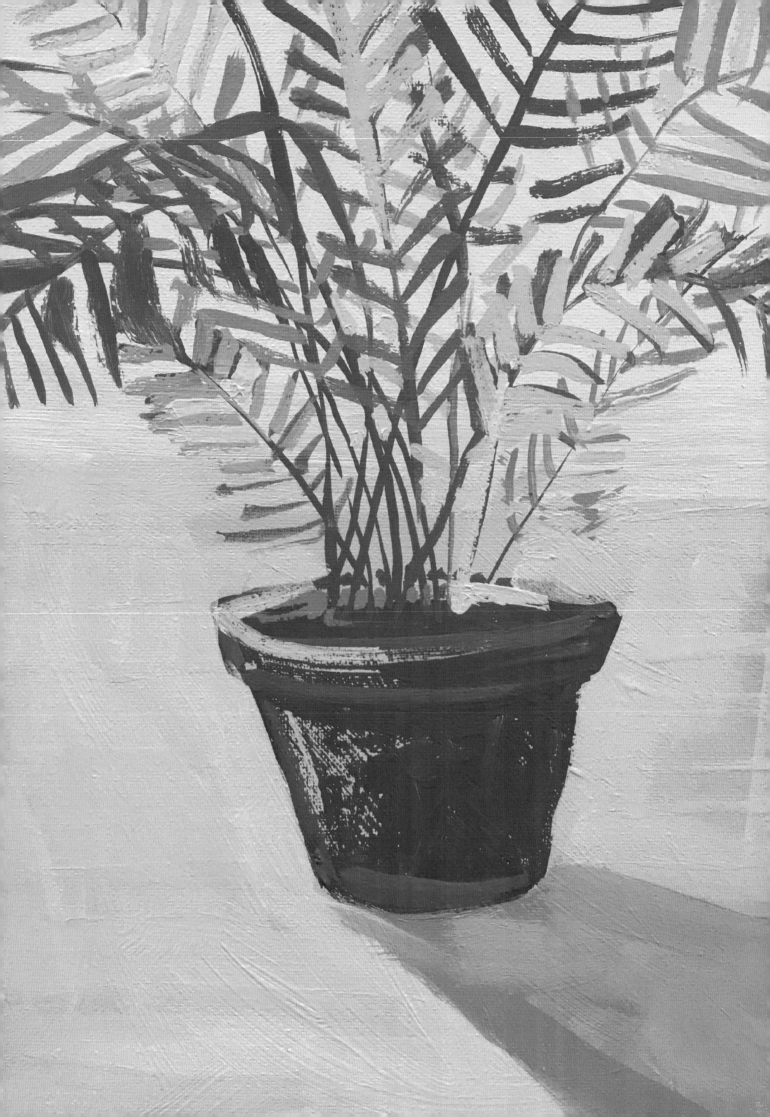

PAINTING
BOTANICALS

POTTED FERN

This potted fern is easier to paint than it may look. It only takes a few paint strokes to create the leafy foliage, making this a great project for beginners!

On a blank canvas, create a table line about two-thirds of the way up. Paint the bottom section pink and the top section an almost-white pink. I mixed red, white, and a touch of brown to create these two pink shades.

In the center of the canvas, paint the pot, leaving out the back where the fern will go. Follow the curves of the pot with your brushstrokes. With a dry brush, lightly paint the left side of the pot, allowing the background to show through and help shape the pot.

Paint the pot's shadow on the table, and use dark brown to fill in the pot.

With a watery green, create the fronds' stems.

Begin to fill in the fern leaves. Think about how they will turn as the branch turns, and their varying lengths. Use lighter green to indicate the leaves in the back.

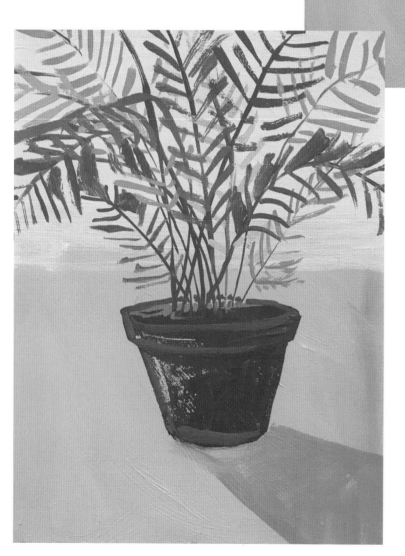

Add some white to the green, and paint the top left leaves where the light hits most brightly. Fill in the back of the pot around the leaves poking out of the dirt. Continue to add fern leaves.

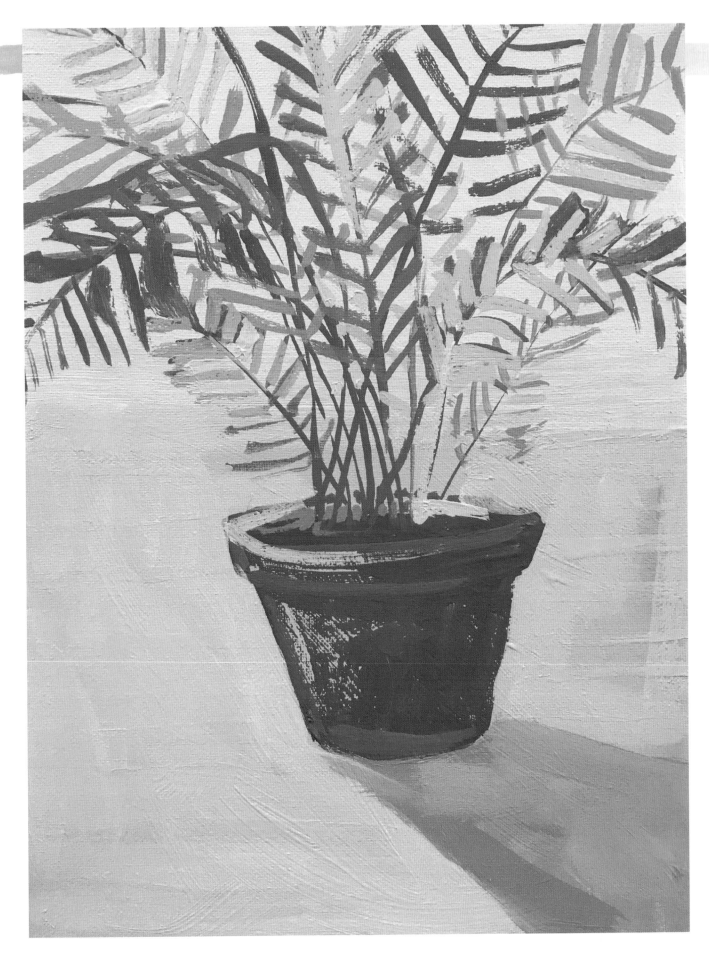

Lighten the table so that the pot and shadow are more in contrast.
Unify the painting by extending the pink color into the fern's leaves.

VASE OF
FLOWERS

A wood panel creates a nice warm undertone for any painting. I encourage you to try this next tutorial on a wood panel, but you can also use canvas if you prefer.

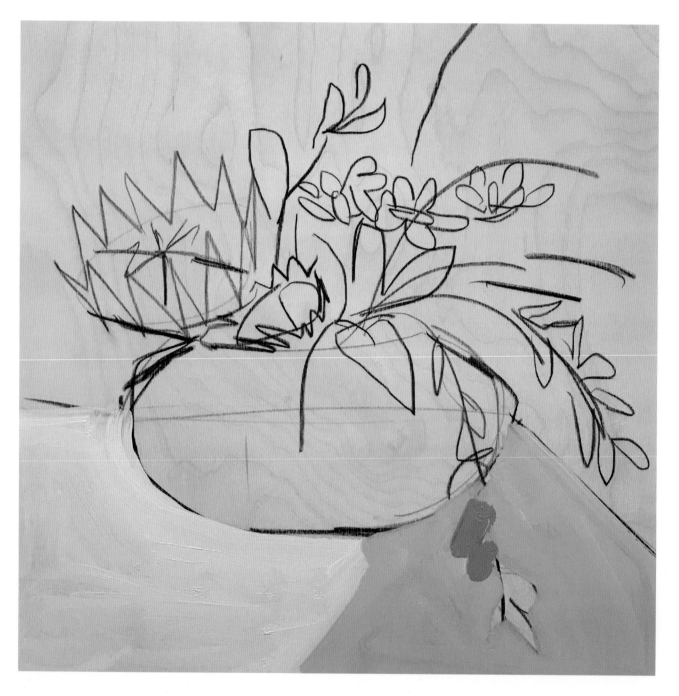

With a bold colored pencil, loosely sketch the floral arrangement on a wood panel. I chose cobalt blue to contrast with the more neutral paint tones I plan to use. I like to hold the pencil near the end, which allows the pencil to move more freely.

Block in a medium brown on the right side of the table, and add white on the left side where the light source hits.

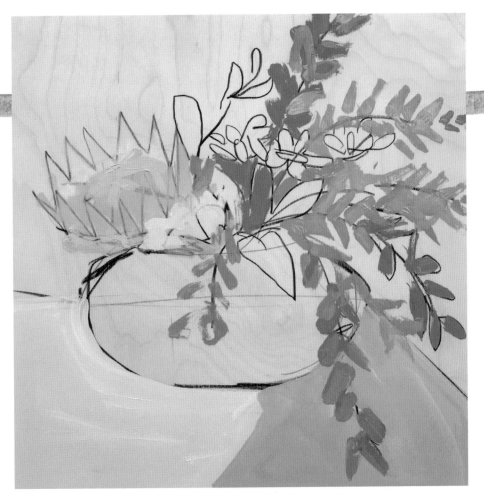

Mix three shades of olive green: dark, medium, and light. Think about the light source and which leaves will be lighter or darker. Loosely fill in the leaves without covering all of the blue pencil lines.

Mix a bit of cadmium red into the brown color you used for the table, and add white to create a neutral pink color for the large protea flower. Again, consider the light as you fill in darker and lighter pink tones.

Use your darkest green to add contrasting leaves in the arrangement. Then use yellow ochre and white to create three tones of cream. Use these tones to fill in the smaller white flowers on the right. Mix some of the green tones with white to round out the white vase.

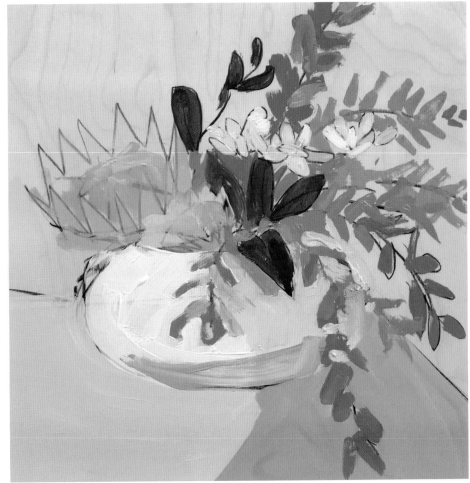

For the background color, make a thick mixture of light blue with lots of white, a touch of Payne's gray, and a touch of ultramarine blue. With a small brush, fill in the color around the floral arrangement. Cleaning up the edges of the leaves by covering them in this blue adds a dreamy quality to the florals. Use a thick application.

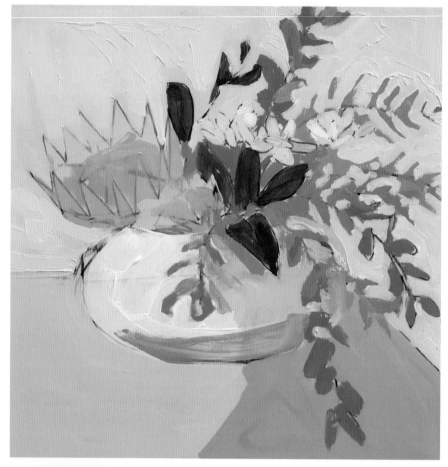

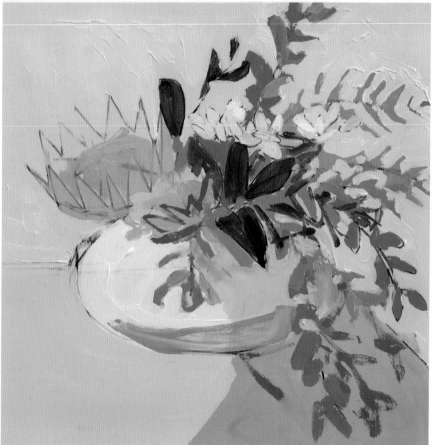

Use your darkest brown to add some shadows on the table and detail in the protea flower.

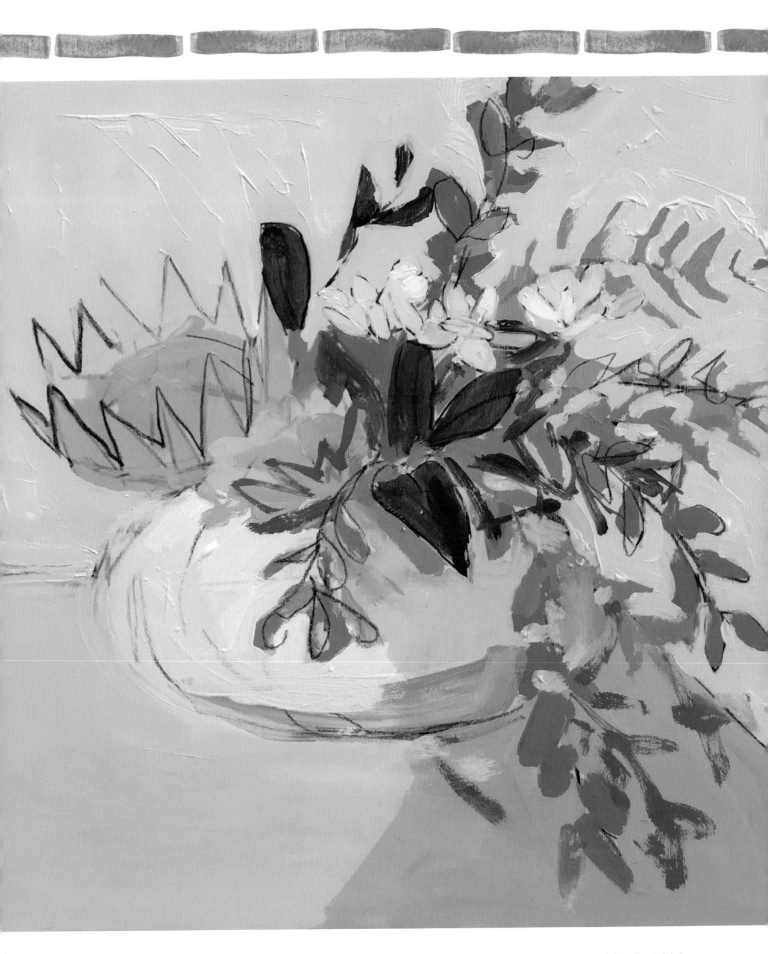

When the paint is dry, use the same colored pencil you used for the initial sketch to rework some of the original lines that have been painted over.

 COLLAGED

BOUQUET

To create this collage bouquet, you must first make all the pieces. This unique twist on painting is a fun way to explore building a complex image without worrying too much about the process. You can rearrange the individual pieces until you find the composition that you like best!

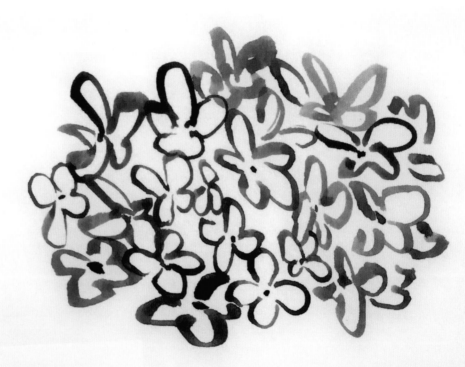

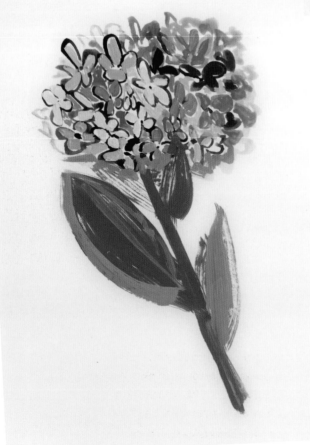

Start by creating detailed flowers. For this hydrangea, paint the outlines of a bunch of bold, blue flowers, arranged in an oval shape.

Fill in the petals with different tones of blue. Notice how I made the flowers on the right side less detailed, so they look as though they curve backward. Add the green stem and leaves.

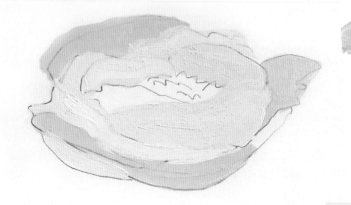

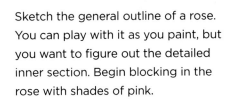

Sketch the general outline of a rose. You can play with it as you paint, but you want to figure out the detailed inner section. Begin blocking in the rose with shades of pink.

Build upon that inner sketch, and continue painting and blending the pink petals.

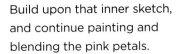

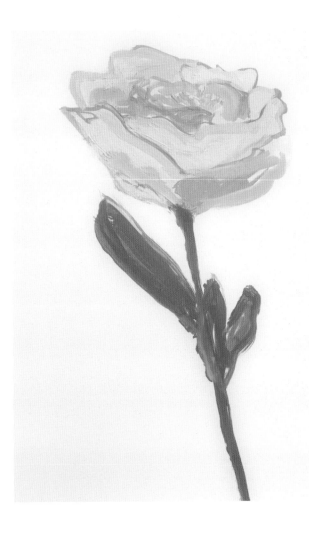

ARTIST'S TIP

Don't add too much detail when you paint the stems— you want the flowers to stand out the most!

Detail the edges of the petals with darker pink. Make sure the bottom of the rose is a cone shape, so it easily leads to the stem. Add the stem and leaves.

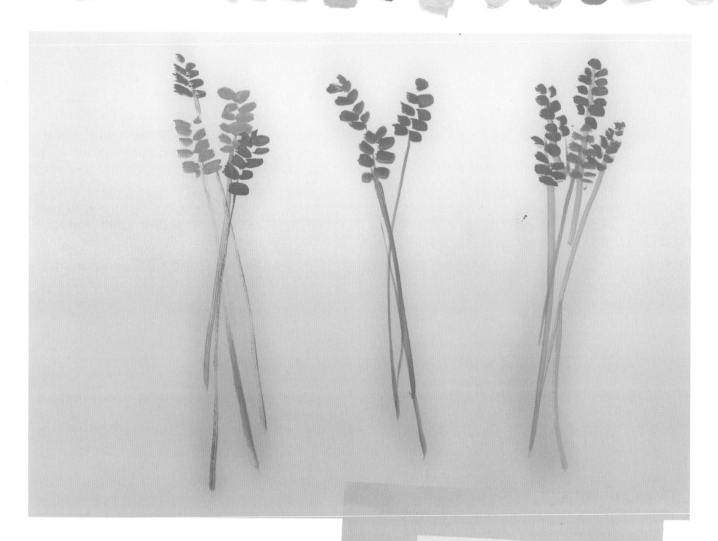

Next paint a few smaller, bundled add-ins, like these pieces of wheat, in the same color as the rose, using some simple paint daubs and long strokes for the stems. Make sure to create an odd number of these add-ins.

For background flowers, mix water in with the colors you've been using, and create just the general shapes of the flowers. You don't want these to be detailed; they will just fill in the background.

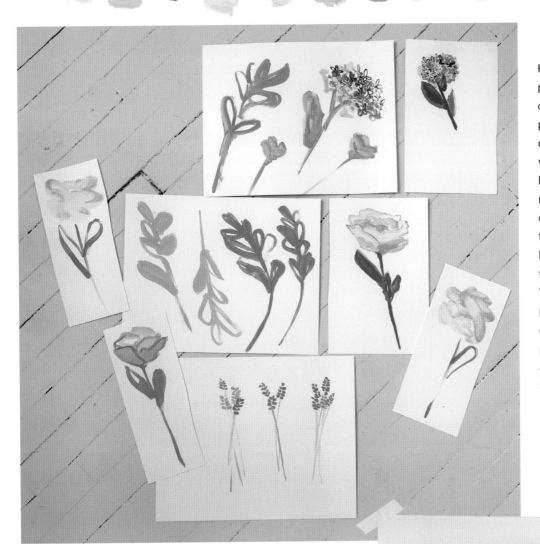

Here you can see all the pieces I created for my collage. I made some pieces of greenery, two detailed hydrangeas, two washed-out background hydrangeas, one detailed rose, one washed-out background rose, two small roses, three bundles of wheat, and five stems of leaves. When you're done painting the flowers, cut out each individual piece, trimming away as much of the paper as you can.

On a separate piece of paper, cover the background with an accent color. I used gray-blue and painted it in a gradation that's dark at the top right and gradually lightens as it reaches the bottom left.

You can decide how to glue
the flowers down as you go,
or you can place the pieces
first to find the composition
you like best. Then just snap
a quick photo to refer to as
you glue down the pieces.
Begin with the washed-out
pieces in the back.

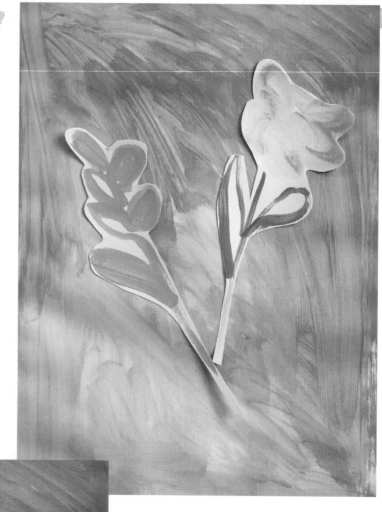

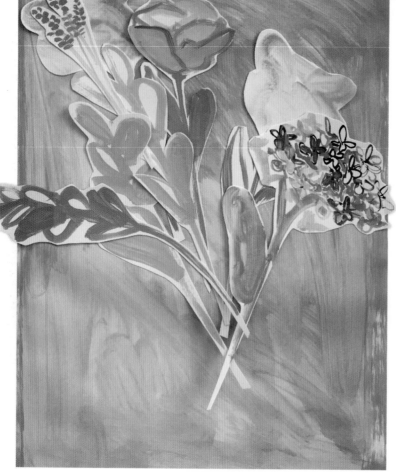

Group all the background
pieces first before you
begin adhering the more
detailed pieces.

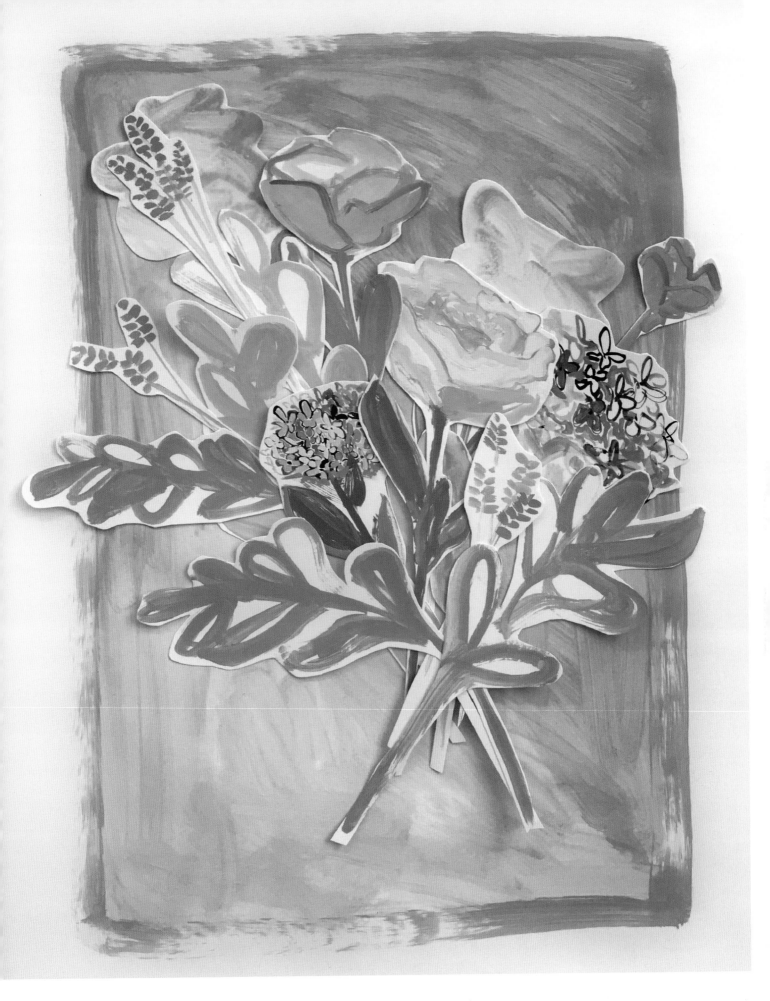

The final product should have greens in the front, flowers in the middle and back, and extra smaller pieces delicately sticking out of the bouquet.

PALM TREE

One of the great things about painting with acrylic is that you can combine different media to achieve unique results. In this tutorial, we'll work on paper, and then accent the finished piece with colored pencil and oil pastel.

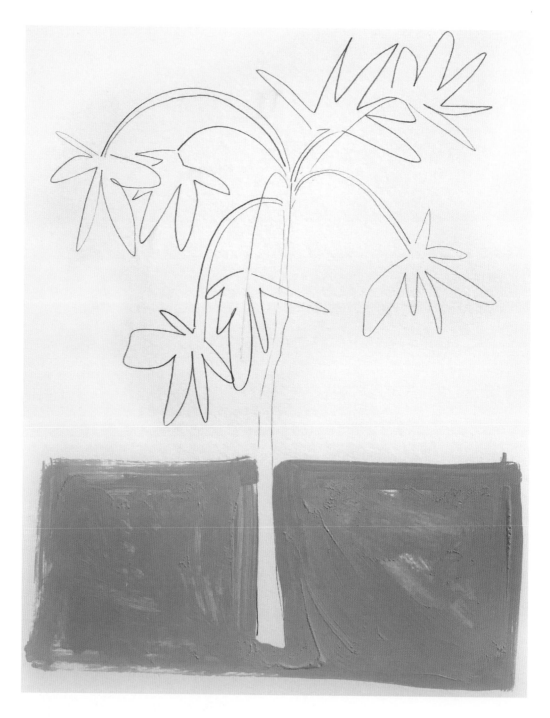

Tape a piece of watercolor paper in place with artist's tape. Then use pencil to draw the outline of the palm tree. Think less about the detail of the tree, and instead focus on the overall shape. Choose the color you'd like for the background, and paint the bottom third of the page. I mixed ultramarine blue with a touch of yellow and lots of white to make a nice aqua. Keep the paint somewhat thick, and don't dilute it too much.

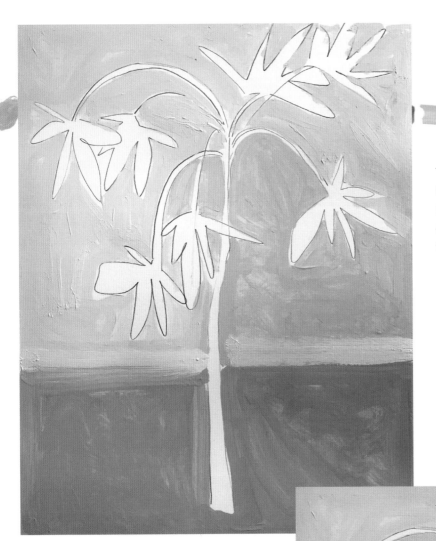

Then add white to the background color mix, and block in the top two-thirds of the background without filling in the palm tree.

Mix white and yellow for the first tropical plant in the foreground. I used a filbert brush to paint loose heart shapes. Then mix red with a touch of yellow and white to create a coral color for the second plant. Use light, brushy strokes with a flat paintbrush.

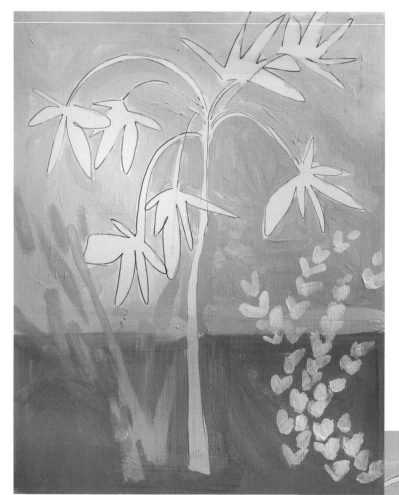

Use clean water and a large paintbrush for these next marks. With a touch of yellow mixed with lots of water, paint a light wash of yellow across the top corner of the palm tree. Do the same thing with orange on the trunk of the palm tree. The more colors you cover with the wash, the more tones you will create.

With the tip of a rigger paintbrush, use yellow ochre to create a dainty plant that weaves in and out of the first yellow plant you created.

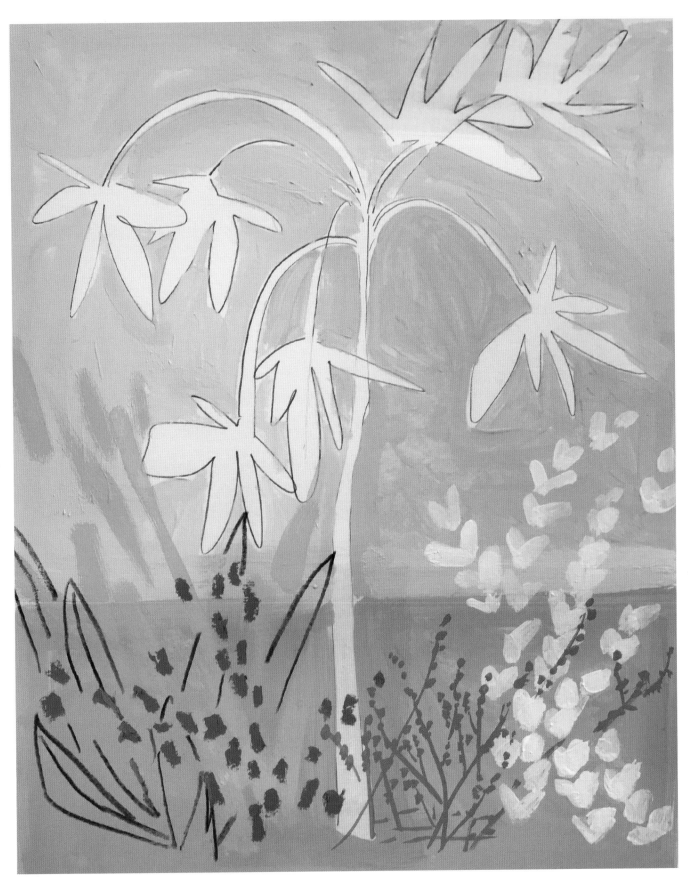

Now is the time to apply some different materials! Use a colored pencil for the banana leaves on the far left, and make some teal dots with oil pastel on the coral plant.

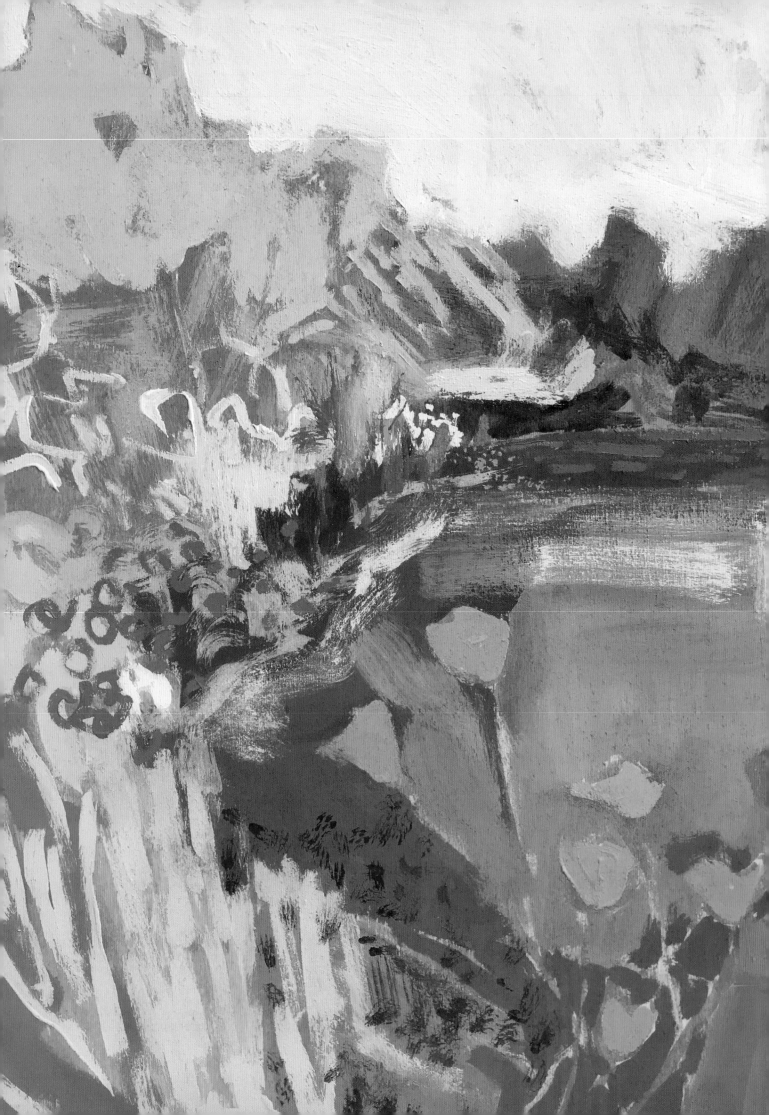

PAINTING
ARCHITECTURE & LANDSCAPES

EUROPEAN CAFÉ

There's something so appealing about a quaint European city street. Full of texture, history, and color, there's no shortage of painting inspiration to be found in this part of the world.

Start by sketching out the scene on canvas or a panel. This particular scene has a very distinct foreground and background to help capture that quaint feeling.

Begin to block in the colors, but try to limit your palette to neutral colors for the buildings. Think in tones of gray, beige, muted green, and brown. Use a pretty cobalt blue for the water.

Draw the colors from the foreground windows and shutters into the simple dots and lines of the background city.

The background city can have loose, whimsical details, while the foreground should be more detailed. This will help visually create distance and depth in the scene.

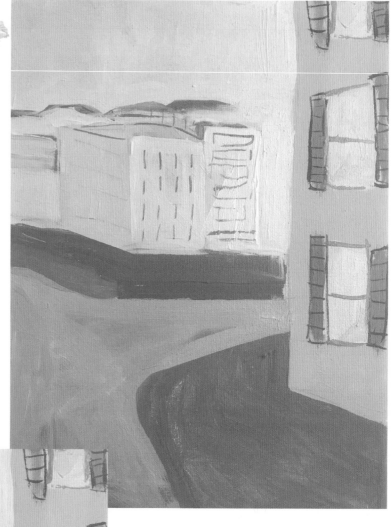

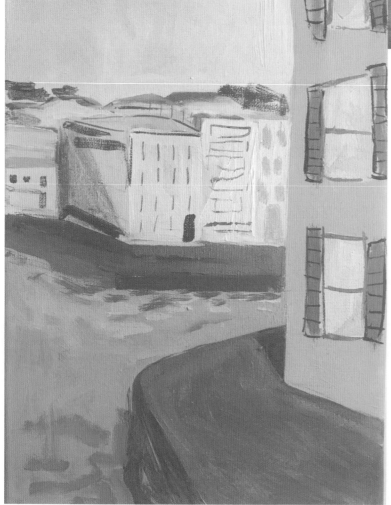

Think about the highlights and shadows of the scene. Use pure white to add highlights, and deepen the shadows on the left of the buildings. Adjust the sky and water to better blend the neutral colors in the buildings. Add those same dots and lines to the water to create a reflection.

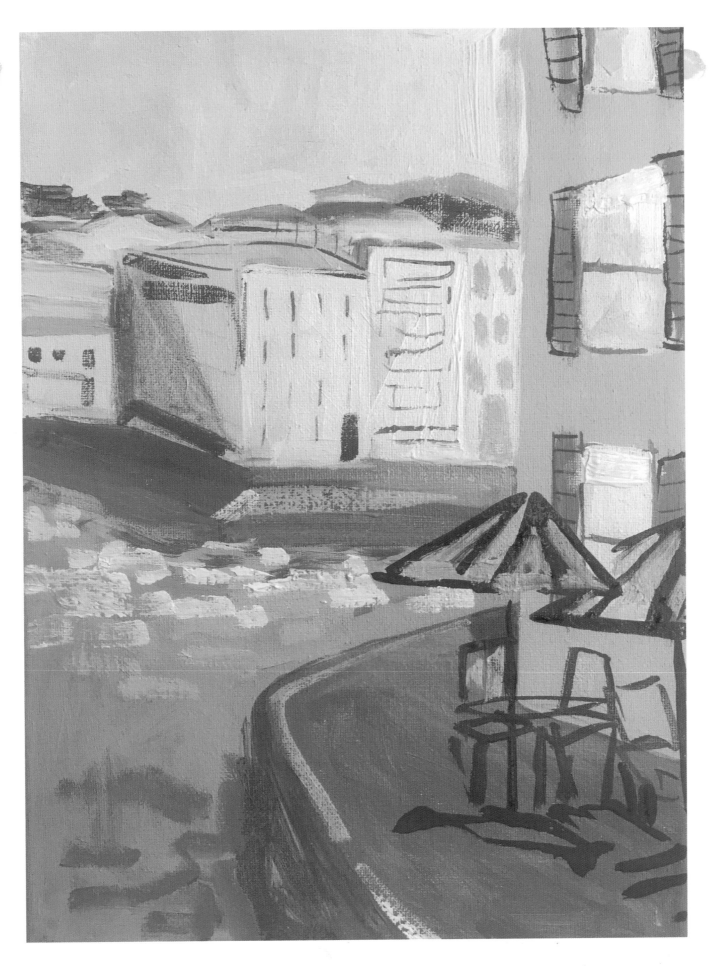

Finally, add a loose line foreground illustration
of the umbrellas and café tables.

 COASTAL

SCENES

I grew up near Annapolis, Maryland, and spent countless hours in the family boat. Moments on the water made my heart sing, and now coastal scenes are one of my favorite things to paint!

TRAWLER

Mix a turquoise color for the water, and put the horizon line about one-third from the top of the canvas. Then add white to your turquoise color to create a lighter shade for the sky.

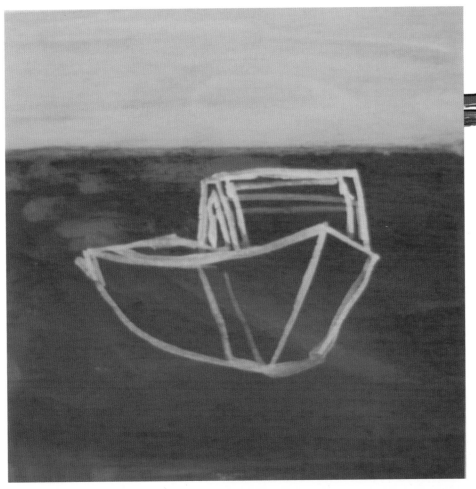

With watered-down white paint, sketch the boat with a rigger brush. Continue to work on that underpainting until you see the boat take form, applying more turquoise paint to build depth.

Use pure white to block in the right side of the hull and the top of the boat. Add a touch of aqua to the white to differentiate the left side of the hull. Because water reflects light, add pure white to the bottom left side of the hull. Then use a darker turquoise to block in the windshield and side windows.

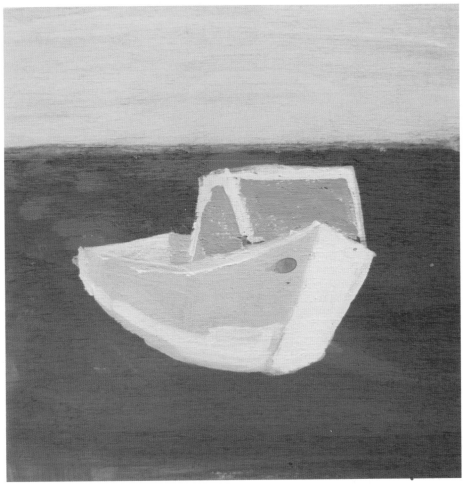

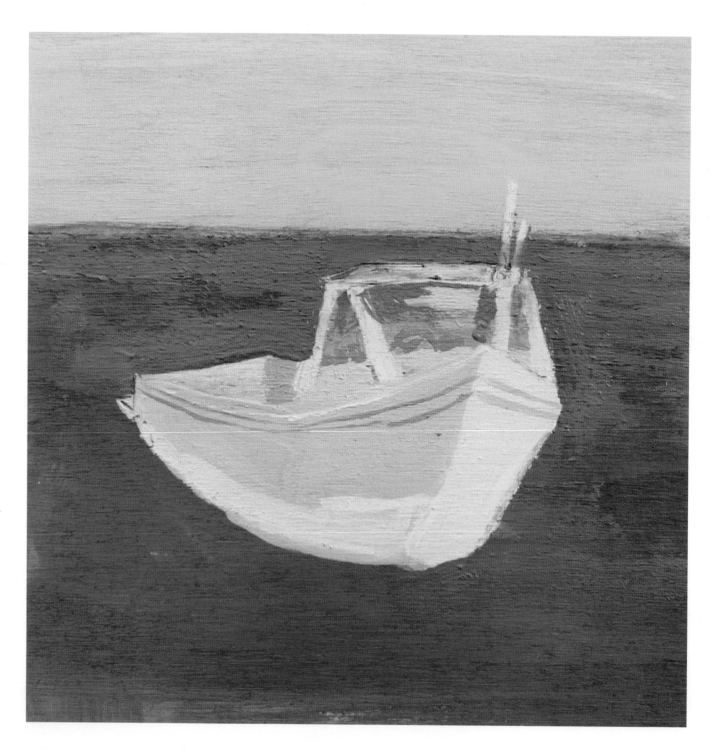

Add some green to the aqua, and wash in the background water. Be sure to include this color in the windows as well, since you can see through the glass to the inside of the boat. Add a steering wheel and some details on the dashboard.

Scratch in reflections with the handle of a paintbrush.

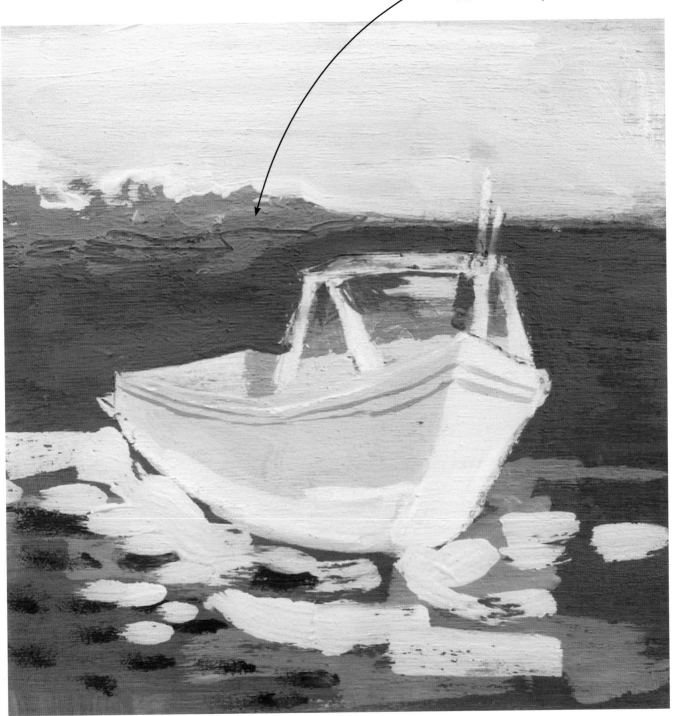

Use all the colors you have used in the painting to create a nice "dashed" reflection. To add depth to the painting, paint some loose pieces of land, focusing on the tree line.

SAILBOAT

Start with a light color for the sky and a darker tone for the water, placing the horizon line about one-third from the top of the canvas.

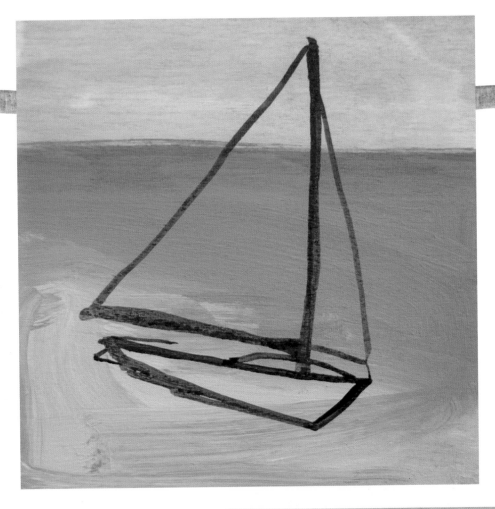

Water down some Payne's gray, and outline the sailboat. You might find it helpful to use a reference photograph for the boat.

Roughly block in the white sail. Then add ochre to cobalt blue to create a nice navy with a green undertone, and paint the bottom of the boat.

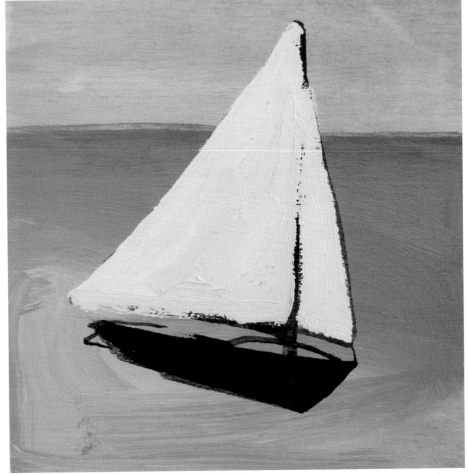

Loosely paint the mast and boom for the sail with ochre. Begin working on darkening the water in the background and lightening it as it comes forward. (Follow the tips on page 18 create a graded wash.)

Using loose, rough strokes, add a rough tree line on the horizon and a nice reflection in the foreground. To fill some of the middle space, add some very simple triangles with hulls to suggest other sailboats.

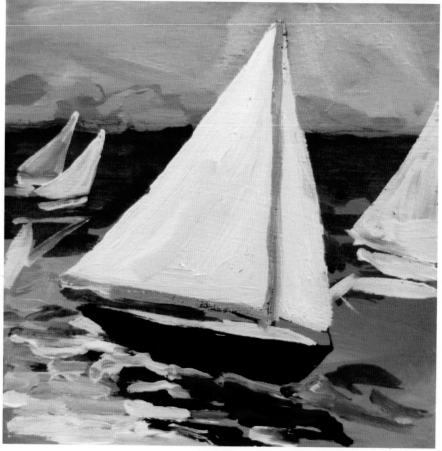

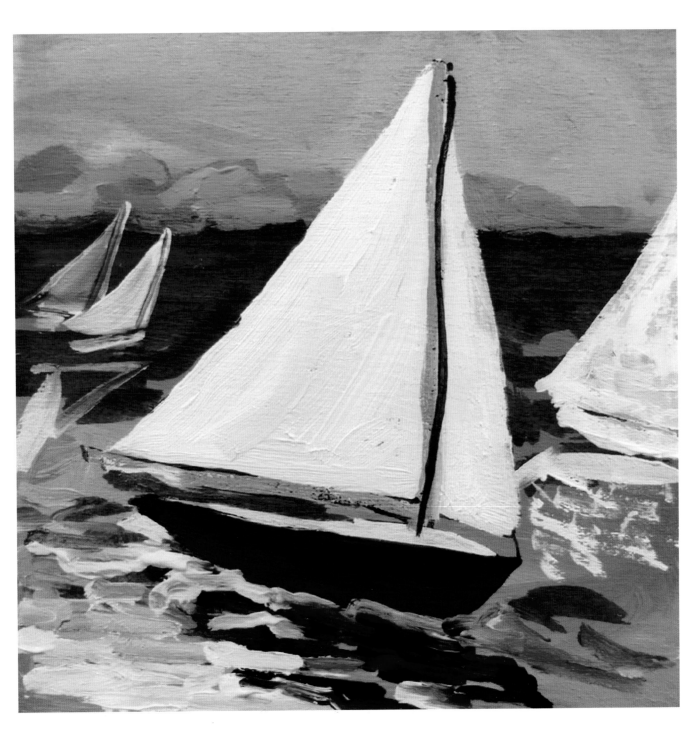

Finish by sharpening some details, creating more
reflections, and playing with the texture of the sailboats.

ABSTRACT
LANDSCAPE

For this project, let's explore using a wide range of color to make each level of terrain stand out in this colorful, abstract landscape.

Start by painting the whole panel white, leaving some texture and brushstrokes visible.

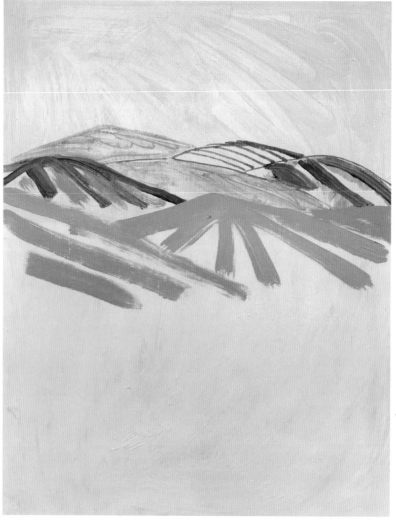

Working from top to bottom, wash in a light blue sky color. Then, with a thin paintbrush, use a bold blue to create linear mountains off in the distance. Using a filbert brush, mix a light lavender for the foothills. Paint only two or three of these, so they're bigger than the background mountains. Extend a bit of the lavender into the mountains to connect the two layers.

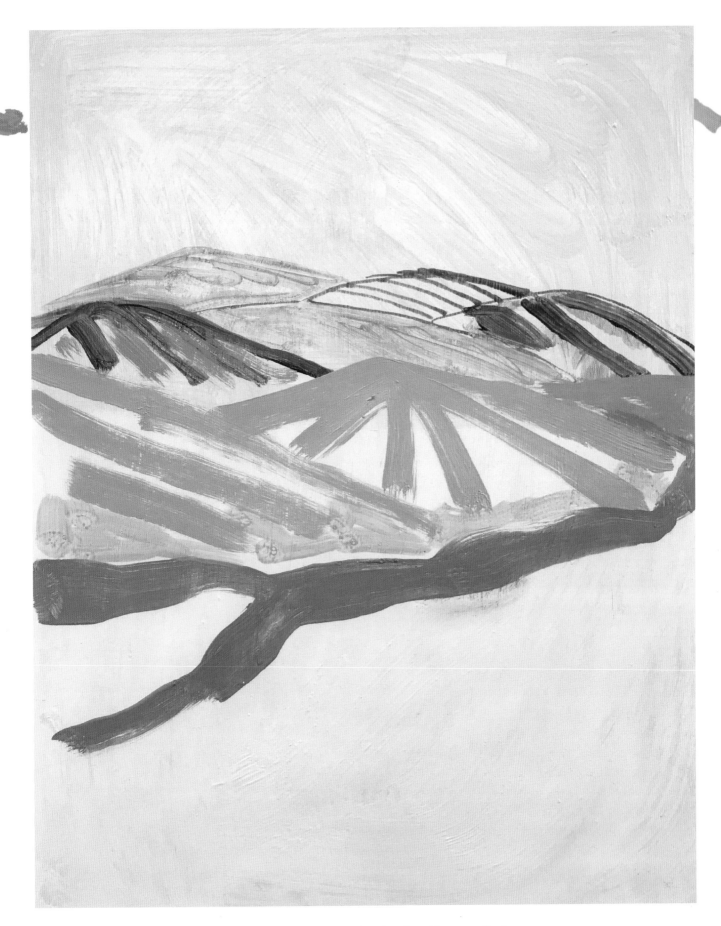

With lime green, draw into the foothills to create a valley for the river. Then use that same bold blue from the mountains to paint a winding river.

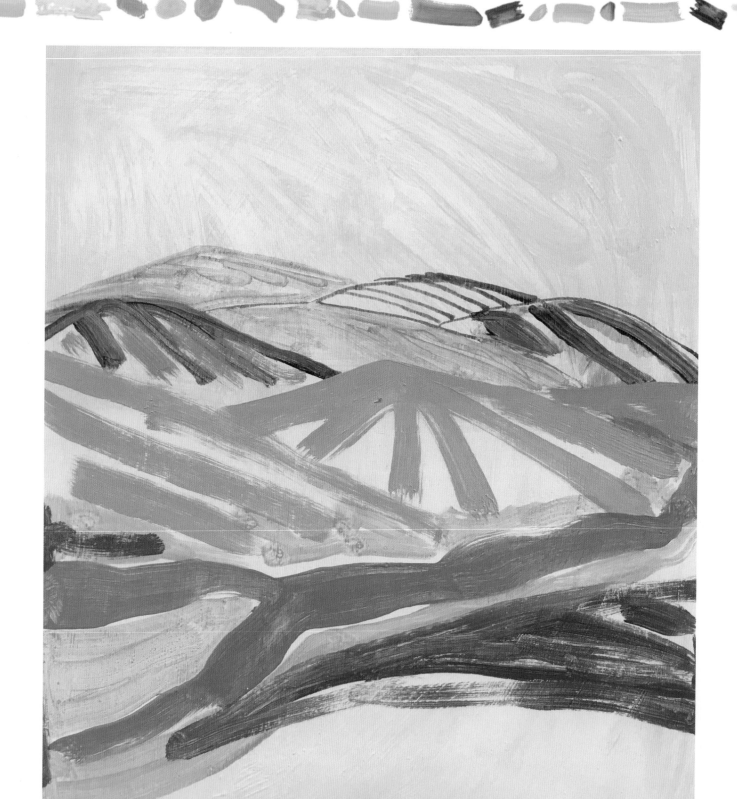

Fill in the area around the river with lime green and dark olive green. Make a curved, oblong triangle to show the foothills coming out of the valley on the right side.

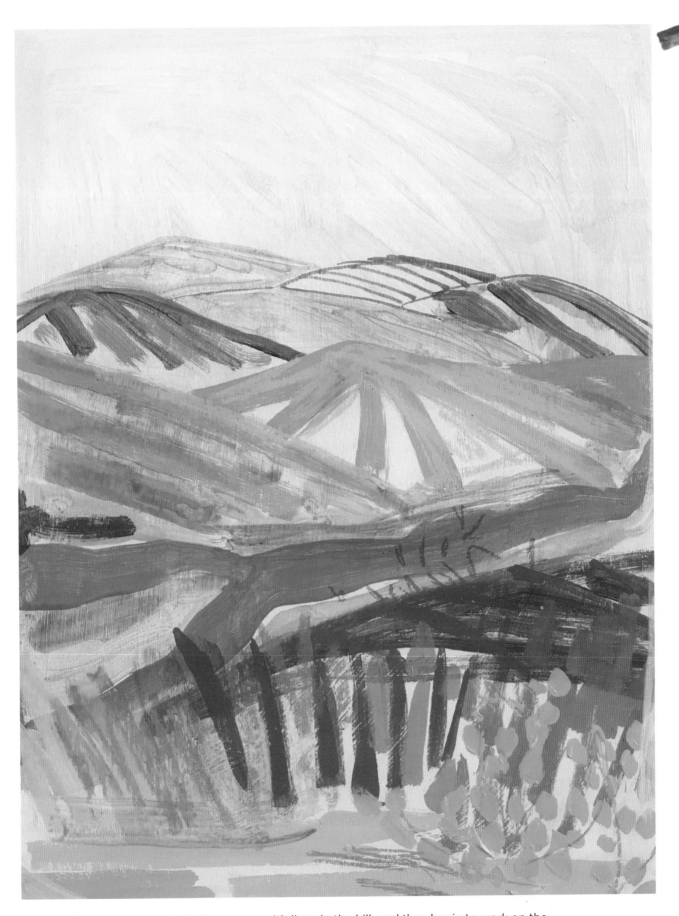

Using yellow ochre, accentuate the curves with lines in the hill, and then begin to work on the grasses in the foreground. Start with yellow on the left, and gradually work through ochre, orange, and red on the right side. Add some pink dots to fill in the red grasses. Finish by using oil pastels to blend the yellow into the red grasses.

GARDEN

At first glance, painting a garden scene may seem overwhelming, because there are so many details. But if you work step by step, from back to front, it's not so intimidating. You can incorporate as much or as little detail as you like.

First, sketch the garden on paper with pencil, and then recreate the sketch on wood panel or canvas using yellow ochre. For this sketch, I started with a curved line and focused on using large shapes in the foreground and small shapes in the distance.

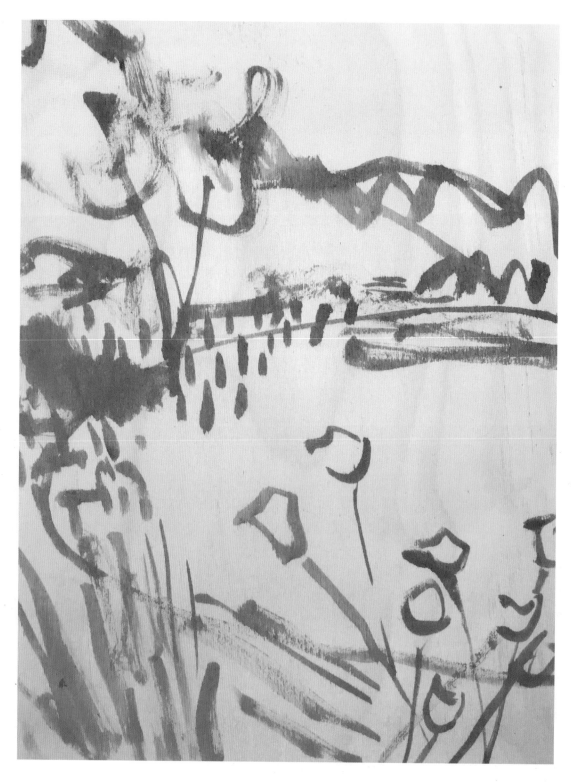

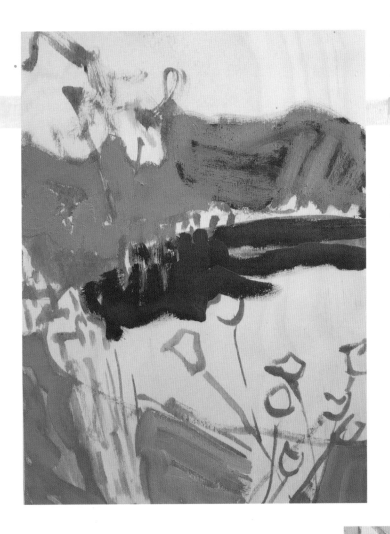

Block in the background and foreground with two shades of green, leaving the ochre outlines visible.

Make a few lighter and darker shades of green, and continue to block in these colors, leaving space to block in flowers.

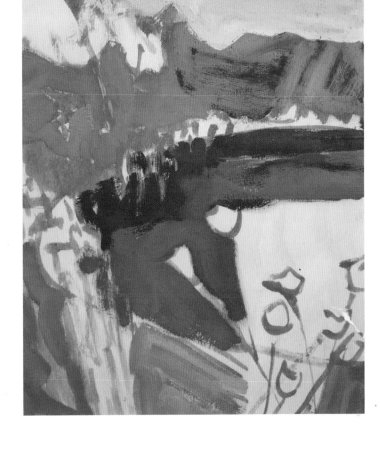

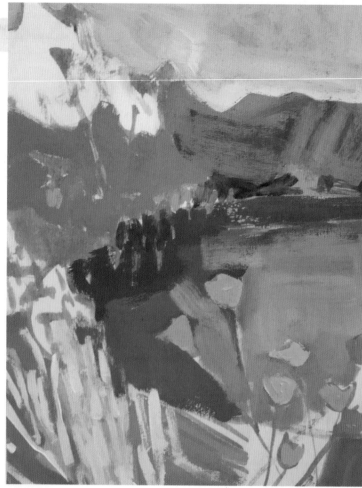

Mix red with white to create bright pink, and fill in the front flowers. Then draw that color into the background as well. Using dark blue, bring some shadows into the background. Then add white to your blue, and add some up-close reeds in the bottom left.

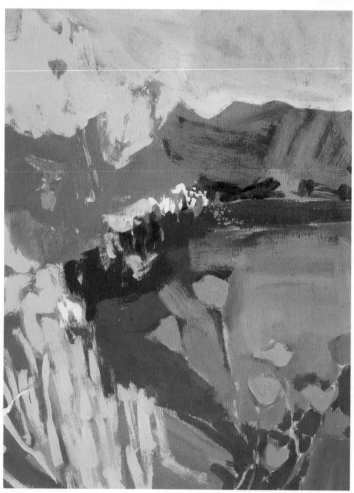

Block in the closest trees with light green, allowing the yellow ochre to show through. Use light ochre to work highlights into the background, and add some brighter greens to the front.

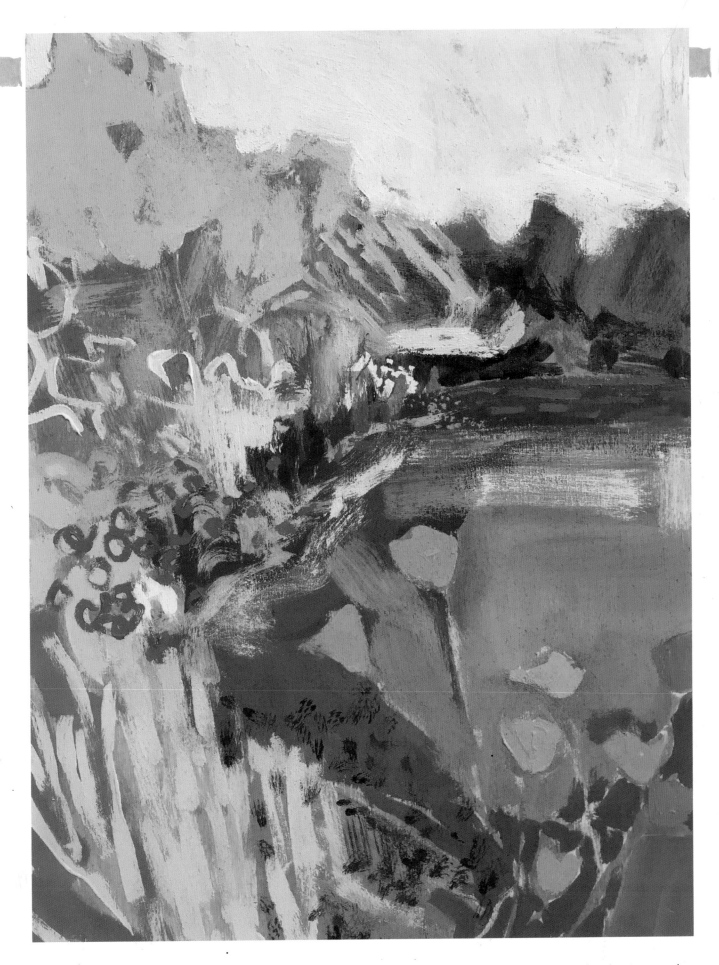

To finish, use simple shapes to create more details. Brown circles mimic a flowering bush without drawing too much attention from the foreground. Add a lighter green to the middle-ground trees. Apply some brushy details, and lighten up the sky. I also edit the tree line in the background by covering some trees with white.

ROAD

The secret to a convincing landscape is atmospheric perspective—the effect when faraway objects become almost blue-gray as they lose detail, clarity, and color when receding into the distance. With a few simple painting techniques, you can suggest depth and distance.

Start by using pencil and paper to sketch out the general scene. Think about perspective; filling the space, light, and composition; and getting the road to lead the vanishing point. A curved horizon line mimics a mountain top.

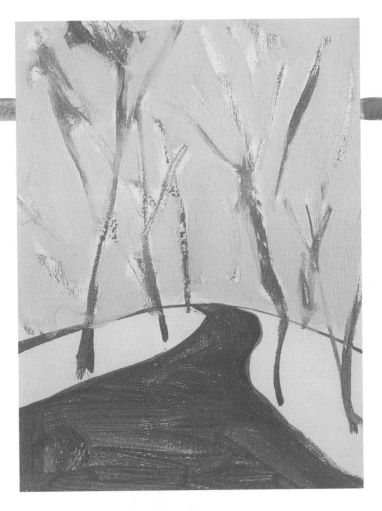

Next, use your sketch to map out the underpainting. Begin to outline the tree trunks. Note that as the road gets small, so do the trees. Fill the entire sky with a light sage color, but leave the trees untouched. Mix green with Payne's gray to paint the gray-green road.

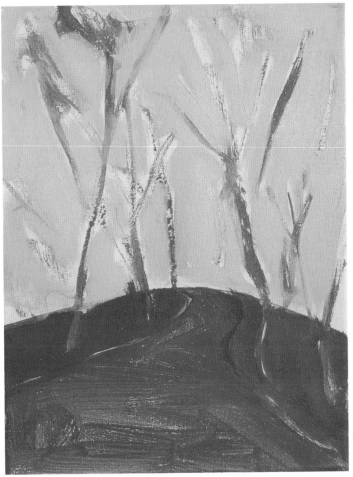

Fill in the forest floor with dark green, and make sure the color differs slightly from the road.

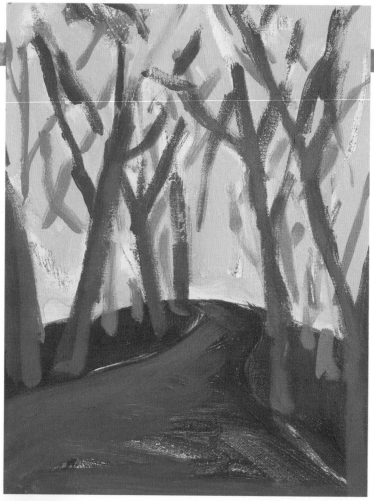

Now choose a few foreground tree trunks to add detail to while allowing the others to fade into the background. Use burnt sienna to accentuate the trunks. Then mix green with white and yellow ochre, and lightly brush in lines for the background trunks. Fill the painting with trees without adding detail to each one.

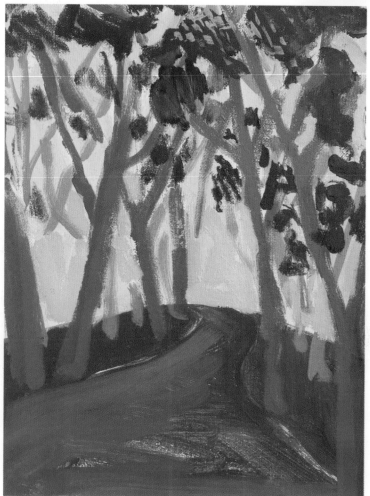

Begin to loosely brush in the leaves. Add brighter patches of color for the trees in the foreground and darker, smaller patches as they recede into the distance. Use an even lighter green to add small dabs of paint and create more detail in the closer leaves. Then make a slightly darker shade of the sky color, and fill it in toward the bottom of the sky to help create depth.

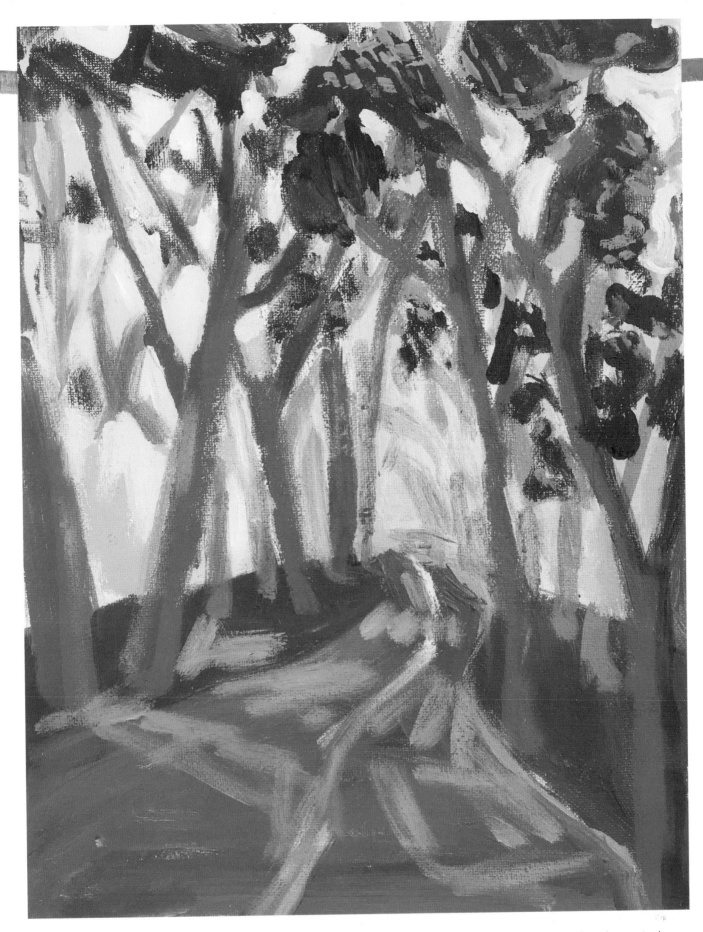

Use the darker sky color to outline the right side of the road and distinguish it from the forest ground. Finally, add light and dark shadows to the road and middle line. Then, with a wash of ultramarine blue, add more background trees and branches through the painting, filling holes behind the trees you've already created and creating the illusion of atmospheric perspective. Now it seems like the road goes on forever and slowly fades away.

CITY STREET

This vibrant nighttime scene of a city street utilizes a complementary color scheme that is bold and vivid.

Start by painting the panel or canvas bright orange.

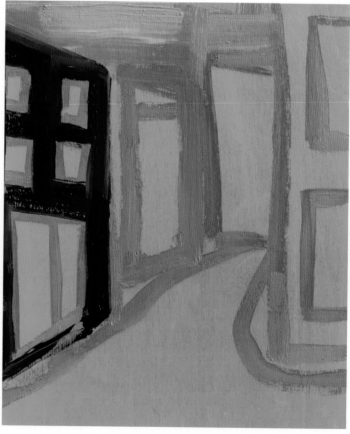

Use bright cobalt blue to sketch in the city. Start with the street, and then work the buildings up from there. Make sure the roofline changes as the buildings change. Then, using a dry brush, paint the sky that same bright blue. Allow the orange to speckle through the sky.

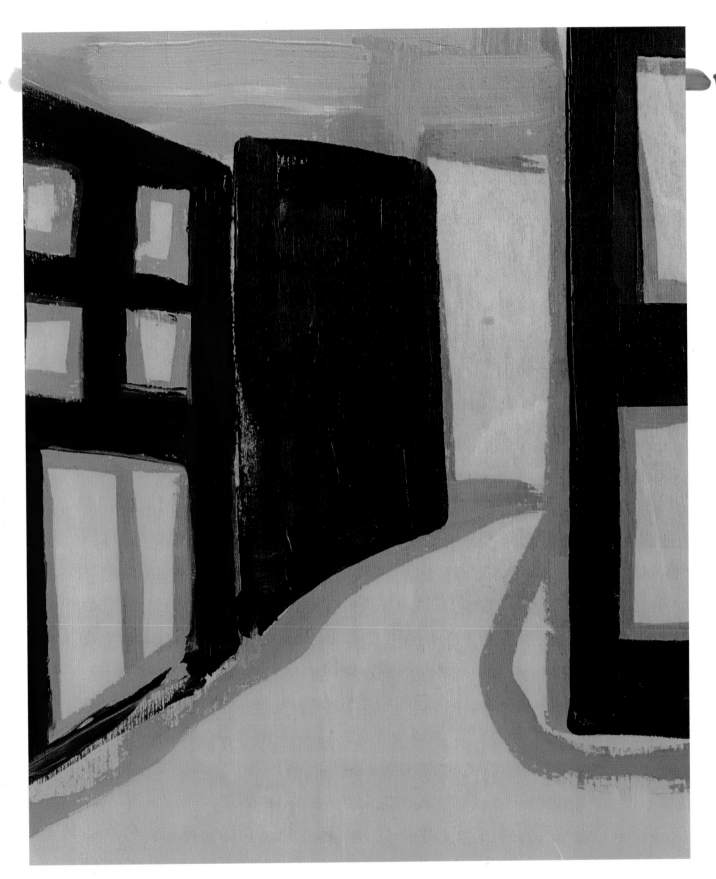

Use dark blue variations to start filling in the buildings, thinking about where the windows and doors will be. In the foreground building, I sketched in the openings so that the orange background glowed through the windows. For the background building, I filled the whole space, and I'll add window light later.

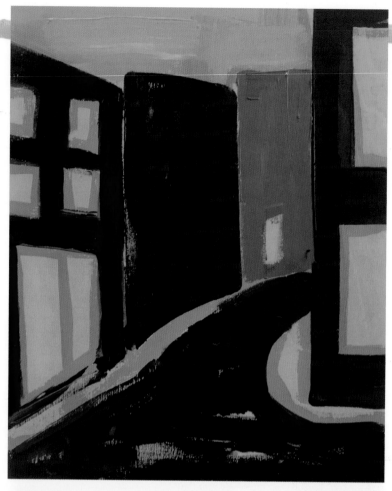

Continue filling the buildings with dark blue shades. Then use the same technique to paint the street as you did for the sky, allowing the orange to speckle through the navy. Loosely paint the sidewalks.

Use the handle end of one of your brushes to scrape off paint for the windows and doors in the second building. With bright yellow, begin to accentuate the light in those first windows, and choose a few in the second building in which to add bright light. Be sure to add the reflection of that light onto the street.

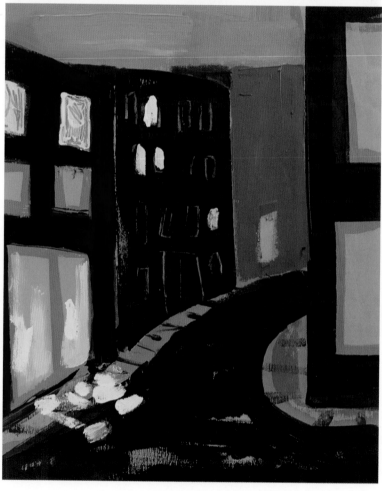

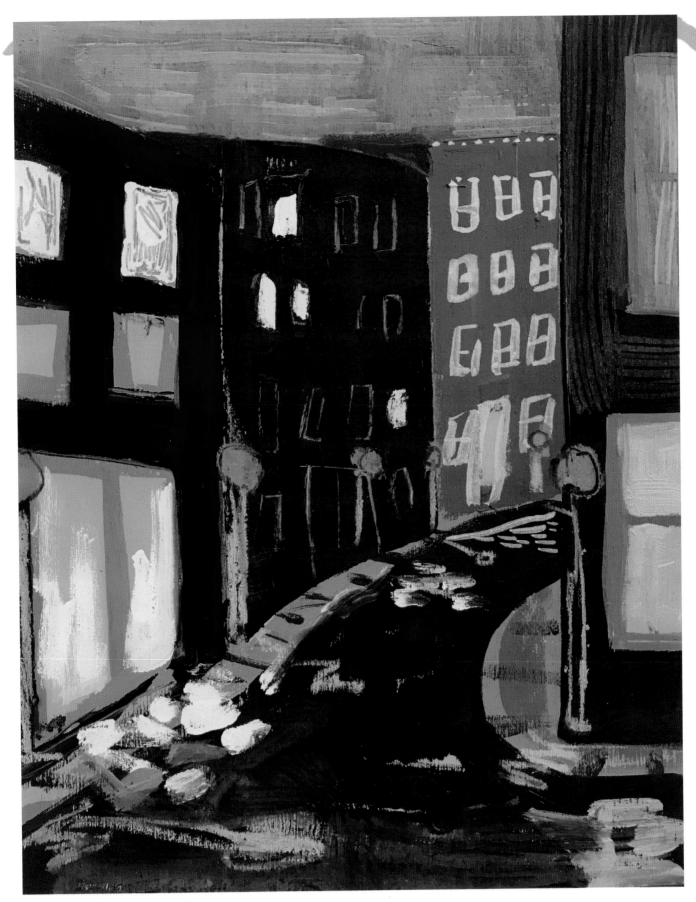

With a thin brush, draw windows on the farthest building and add some detailing to the roofline. Using yellow ochre, add evenly spaced street lamps. Make sure they get smaller as they retreat into the background, and don't forget the loose reflections. Finally, add some water to the palette, and wash in a darker color over the sky and a light color around some of the lights.

MARSH

This colorful landscape offers a great opportunity to explore creating atmospheric depth, creating the illusion of the scenery receding into the distance.

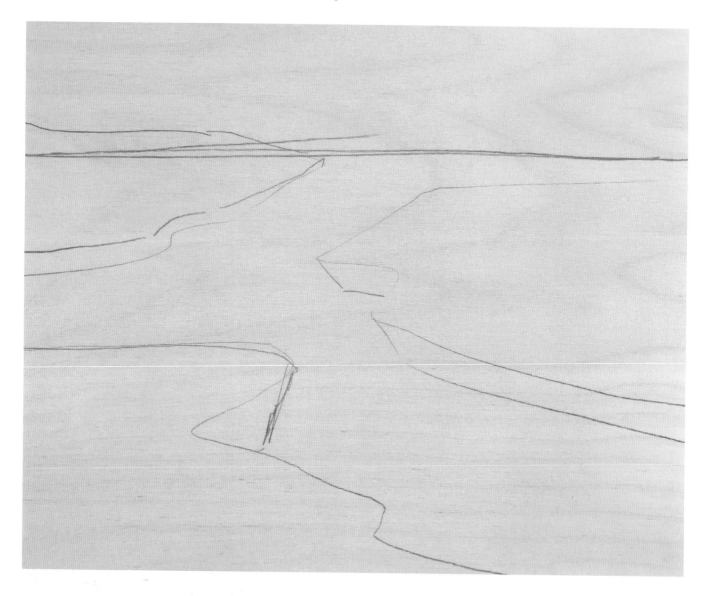

First, sketch out your plan for the marsh on the panel. The masses of marsh will get more detailed as they come forward. Be sure to leave a winding waterway throughout. You can add as much detail as you like to help prepare your piece, but remember that your initial paint washes will cover up your pencil lines. I like to keep the initial sketch simple!

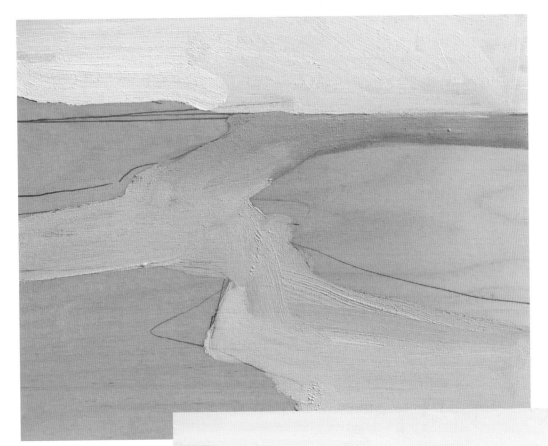

Start by painting the sky white. Then add some ultramarine blue to the white to create a medium blue. Work your way from the back of the piece to the front, only filling in the water. Gradually add more and more white to your mix so that the water gets lighter as it comes into the foreground.

Mix two green tones, a light and a dark. Fill in the masses of the marsh with both tones, blending them together.

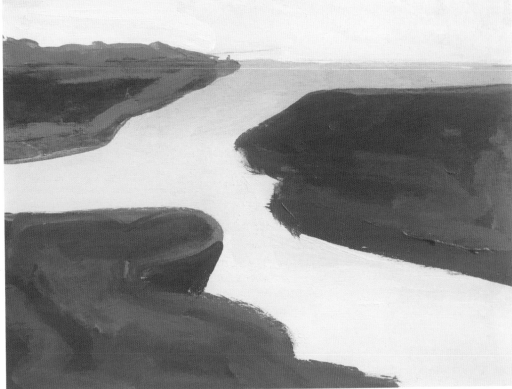

Next, use your light green mix from the previous step as a highlighter. Swipe the edges of the marsh with this color to accentuate blades. Add some single pieces of grass in the foreground.

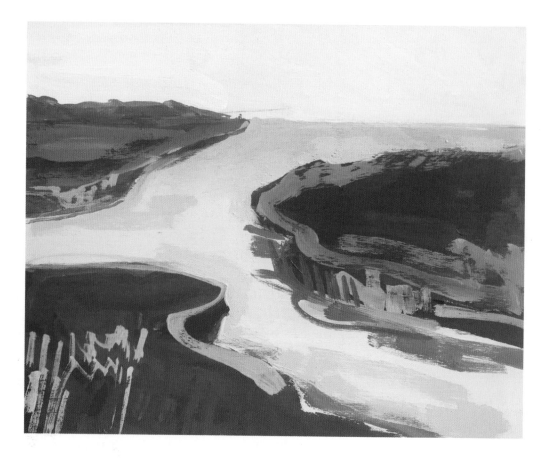

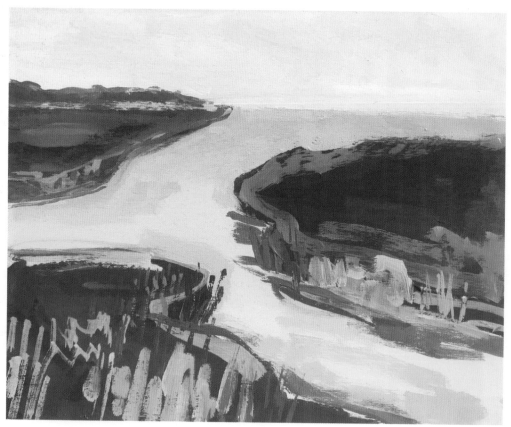

Choose some secondary colors to bring vibrant color into the scene. I chose golden yellow, pink, and yellow-green. Add these colors in the marsh, and continue each color into the reflection in the water.

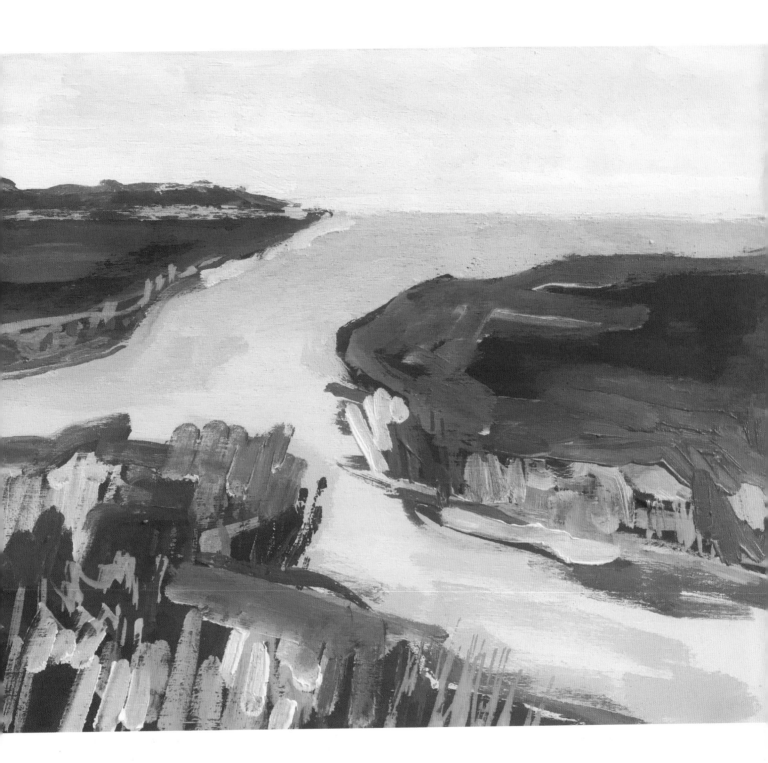

Add more color and detail in the foreground with less in the background to create depth in the scene. Add more blue to the sky, letting the white sky show through in places to suggest clouds.

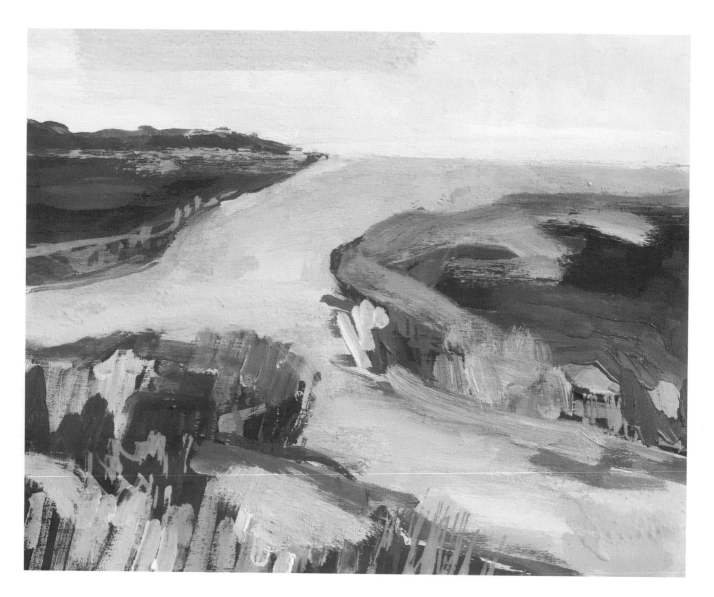

Use small brushes for the details. Then choose a larger
brush to wash in some bolder strokes of color.

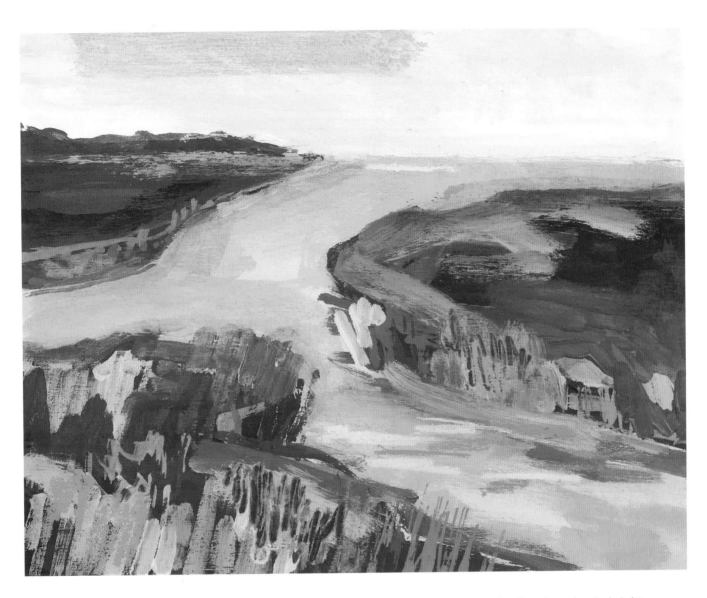

Finish by adding final detail and strokes in bright, vibrant colors that "pop" out of the scene. I used oil pastel for these marks, but you could also use a small paintbrush.

ABOUT
THE ARTIST

Artist **BLAKELY LITTLE** delights in the scenery of coastal towns: their pastel palettes, winding waterways, and upbeat moods. Based in Charleston, South Carolina, she paints the world in unlikely colors meant to inspire a sense of discovery and joy. Blakely grew up in Annapolis, Maryland, and attributes her deep love for the water to her childhood on the Severn River, where her family spent most sunny days out on the boat.

After graduating from the College of Charleston, where she studied arts management and studio art, Blakely began working toward her artistic career. She currently lives downtown with her sweet husband, Curtis, and their adorable Golden Retriever, Posie. Here she has found an artists' community that is rooted in Christ and steeped in whimsy.

Blakely would like to dedicate this book to the other four of the original five: Mom, Dad, David, and Caroline. "Thanks for being the inspiration behind my love of life and color from day one!"

ALSO IN THIS SERIES

978-1-63322-356-1

978-1-63322-492-6

Quarto Knows
Inspiring | Educating | Creating | Entertaining

Visit www.QuartoKnows.com